ANYONE CAN PAINT
WATERCOLOUR LANDSCAPES

Previously published in 2018 as
The Paint Pad Artist: Watercolour Landscapes

This edition published in 2023

Search Press Limited
Wellwood, North Farm Road,
Tunbridge Wells, Kent TN2 3DR

Text copyright © Grahame Booth 2018, 2023

Photographs by Roddy Paine Photographic Studios

Photographs and design copyright © Search Press Limited
2018, 2023

ISBN: 978-1-80092-150-4
ebook ISBN: 978-1-80093-135-0

Suppliers
If you have any difficulty obtaining any of the materials
and equipment mentioned in this book, please visit the
Search Press website: www.searchpress.com

Extra copies of the outlines are are available to download free
from the Bookmarked Hub. Search for this book by title or
ISBN: the files can be found under 'Book Extras'.
Membership of the Bookmarked online community is free:
www.bookmarkedhub.com

Publishers' note

All the step-by-step photographs in this book feature the
author, Grahame Booth, demonstrating how to paint
watercolour landscapes. No models have been used.

Dedication
To Judy for her unwavering support over all the years.
And she still laughs at my jokes.

Acknowledgements
Over the last few years my eyes have been opened to some
of the myriad hoops that must be gone through in order to
produce a book. I would like to thank my wonderful editors
Becky Robbins and Lyndsey Dodd who, along with the staff at
Search Press, have lined the hoops up perfectly.

ANYONE CAN PAINT
WATERCOLOUR LANDSCAPES

6 EASY STEP-BY-STEP PROJECTS TO GET YOU STARTED

Grahame Booth

SEARCH PRESS

CONTENTS

Introduction 6

How to use this book 8

What you need 10

General techniques 12
Preparing to paint 12
How to hold your brush 12
Adding water 13
Creating a smooth, wet wash 14
Creating a graduated wash 15
Mixing colour 16
Colour biases 17
Framing your work 17
Sharing your work 17

THE PROJECTS 18

1. Windmill Hill 20
Aerial perspective 20
Overlapping objects 21
Connecting shapes 21

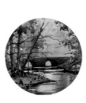

2. Mountain Road 32
Painting convincing silhouettes 32
Creating variety in repeating objects 33
Creating perspective on a mountain road 33

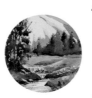

3. River and Bridge 46
Simplifying shapes 46
Creating trees at different distances 47
Reflections 48

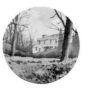

4. Alpine River 60
Directional strokes 60
Connecting washes 61

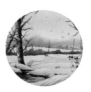

5. Springtime in the Park 72
Integrating buildings into a landscape 72
Creating winter trees 73
Creating drifts of flowers 74

6. Snow Scene 84
Still-water reflections 84
Figures in a landscape 85

The outlines 98

Index 104

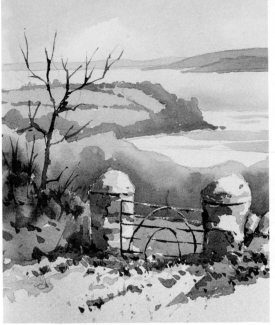

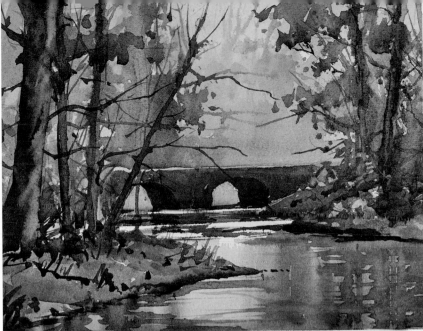

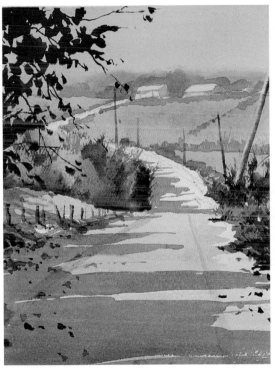

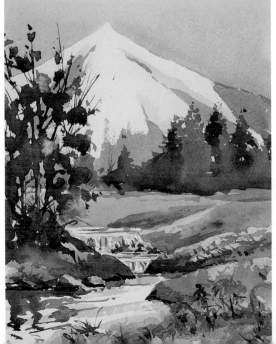

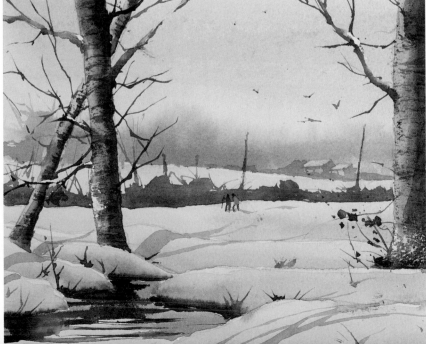

INTRODUCTION

When a watercolour painter first picks up a brush, it is more than likely that the first subject they attempt will be a landscape. I think we all have a basic urge to paint the natural world – more so than the man-made world – and through the years watercolour painters have been tramping through muddy fields and forest tracks in search of the perfect subject. Many people assume that a landscape is easier to paint than, say, a townscape but this isn't necessarily so. Discovering how to paint the various parts of a landscape is part of the fun of learning to paint, but it does no harm to have a little help along the way.

I was about thirty before I started to paint and I still remember my early efforts. How difficult can it be to paint a tree? After all it is just a trunk and a few branches with some clumps of leaves. What about a mountain? Surely that is just like a big rock. Sadly I very quickly learned that things were not quite that simple and before long I enrolled in a local painting class and also began to read as much as I could about watercolour. I have over a hundred painting books lining my studio wall and each of them has helped me on the road to becoming a better painter. I remember at the end of one of the early sessions of classes when we were all saying our goodbyes, I said to one fellow student, 'See you next term', and they replied along the lines of 'No, I have learned how to paint now so I won't need to come back'. I have been painting for over thirty years and the more I learn, the more I realize how much there is still to learn. For me, that is what keeps painting fresh and fun and I hope this book helps you to successfully navigate the never-ending pathway to learning to paint. I should perhaps point out that it can also be immensely frustrating and if you ever feel the urge to throw your brushes out of the window, or if the path seems at times to double back on itself or leads to a dead end, don't worry, this is all perfectly normal. Just keep going, keep practising and keep learning and you will soon be captivated by the beauty of watercolour painting.

HOW TO USE THIS BOOK

HOW TO CHOOSE WATERCOLOUR PAPER

It is important that you paint on proper watercolour paper (for the types I use, see page 11). The outlines of all the project paintings are provided at the back of this book. You can copy them straight onto your watercolour paper or, if you are less confident in your drawing, trace them and transfer them onto your paper using the instructions below.

TRACING THE OUTLINES

The outlines for all the project paintings can be found on pages 98–103. If you would like to trace them and transfer them onto your watercolour paper, follow the steps below, but please also try to draw them yourself. Learning to draw is every bit as important as learning to paint.

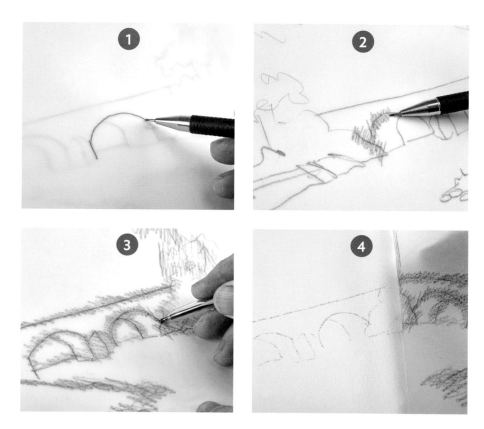

1 Using a sheet of tracing paper, trace your chosen outline. Don't lean too heavily, otherwise you will indent the paper. You can use a pencil or a pen. I suggest a 2B pencil – anything harder can damage the paper; anything softer may smudge.

2 Turn the tracing paper over and lightly shade over the outline with a 2B pencil.

3 Place the tracing paper over a sheet of watercolour paper so that your tracing is on top and the shading underneath. Use a ballpoint pen to go over the outline.

4 Check that the image is being transferred to the watercolour paper. If not, press a little harder with the pen. Aim for a light image, as you can always go over it with your pencil to strengthen it. Pressing too heavily with the pen will give a stronger image but will indent the watercolour paper, causing painted washes to be uneven.

SECURING YOUR PAPER

If your watercolour paper is not securely fixed to a board, it will curl up when wet and cause all sorts of problems with uneven drying. Any flat, smooth board will do. I use corrugated plastic, which is very light, but you can use MDF, hardboard (masonite) or one of the drawing boards sold by art shops.

I use masking tape to fix the paper, as this holds well but is easily removed, leaving an attractive white border. When removing the tape, always pull the tape away from the painting as shown below right. If you pull straight up or towards the painting, you are likely to rip the paper surface. Metal clips can also be used, but the board then needs to be the same size as the paper.

WORKING THROUGH THE BOOK

I suggest reading through the introductory pages first and then reading through each project before trying to paint it. The projects follow on from each other to a certain extent. Techniques learned in earlier projects will be needed in later ones, so it is best to paint the projects in the order printed.

Make sure you have all your materials ready for each project before starting. It is particularly important that your paint is squeezed and ready to go. When a watercolour is started, each stage must be completed without delay. Stopping to look for a brush or to squeeze more paint will hinder the process, as will answering the telephone or the front door. It may be anti-social but your paintings will benefit!

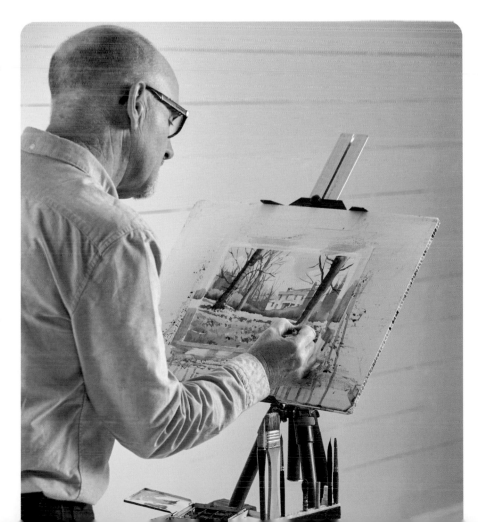

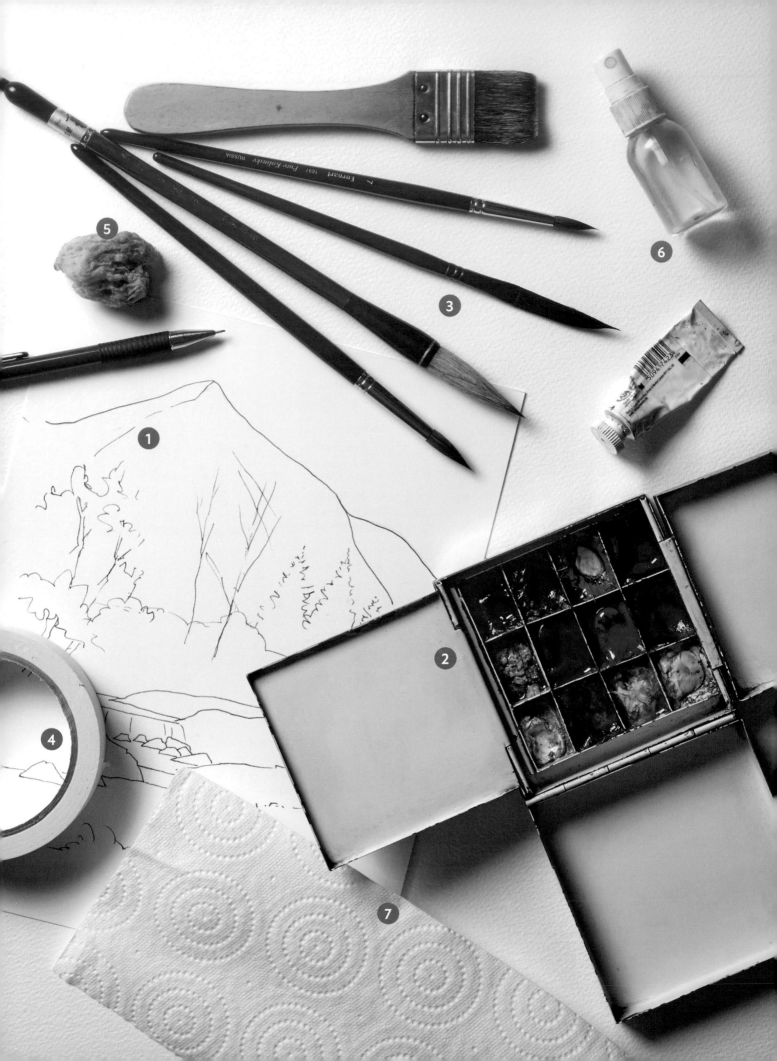

WHAT YOU NEED

You don't need a lot of materials to paint in watercolour. The photograph opposite shows pretty much everything I use and this is almost certainly a lot less than most painters have. Trying out new materials is one of the pleasures of painting but trust me, you don't need twenty brushes!

1 Watercolour paper

Outlines for all the projects are included at the back of the book, and you will need to trace them and transfer them onto watercolour paper. There are many manufacturers of watercolour paper and it is important to find one or two that you like.

The type of paper you use will make the biggest difference to your painting and I would recommend trying papers with a Not or cold-pressed surface and a weight of at least 300gsm (140lb). Rough surfaces are also nice to paint on and they can suit landscape techniques. Do not use hot-pressed (HP) paper. This very smooth paper is not ideally suited to landscape painting and is exceptionally difficult for the beginner to use.

2 Paints and palette

It is important that you use quality paint from one of the major manufacturers. Again, any reputable art shop will only stock good quality paint. Please avoid the very cheap sets of watercolours that you may find in discount shops. Painting watercolour can be difficult; using poor quality paint makes it impossible. While you can use any white plate as a palette, you will waste a lot of paint as it will dry out between painting sessions. Dried paint needs a lot of scrubbing to make it usable and this will damage your brushes. There are handmade paintboxes/palettes that are eye-wateringly expensive, but a basic metal or plastic palette is reasonably priced. Just make sure it has at least twelve deep wells and a good-sized mixing area. I use a paintbox that unfolds into a palette where I can mix my colours. The advantage of a paintbox is that I simply refill the wells with fresh paint from a tube as I need to. There is no waste.

3 Brushes

A brush for watercolour needs to be soft in order to gently apply the paint to the paper. I use only the five brushes shown opposite. From the top down I use a 32mm (1¼in) flat brush that covers the paper quickly with a first wash; a size 7 round sable brush; a small sword liner used for very fine lines such as twigs; a large round brush (I use a Chinese brush) that holds plenty of paint yet has a very fine point; and a size 10 round sable brush. Lifting paint out of your painting requires a scrubbing action, so I use an additional very old size 8 sable brush to minimize wear on my 'good' brushes. The choice of which brushes to use is very personal. My selection changes occasionally as I find a new one that works better for me.

4 Masking tape

I use standard decorators' masking tape (painters' tape) to fix my paper to a board. Ideally you should use a 'low-tack' type, which helps to avoid tearing the paper. You will have heard of the technique of stretching paper. This results in a tight paper that doesn't cockle or wrinkle when wet, but quite honestly it is more trouble than it is worth. Use at least 300gsm (140lb) weight paper and there won't be any problem with the size of paper we are using.

5 Sponge

A small natural sponge is useful to lift out paint from a wet wash. This technique is helpful where you need to lighten an area of wet paint, such as when creating clouds from a flat sky wash. I do not recommend using a manufactured sponge for this as after a short time of use it starts to degenerate and deposits sponge particles on your wash, but such a sponge can be useful to control the amount of water on your brush.

6 Spray bottle

A spray bottle can be used to lightly spray the paper before beginning. This slows down the drying time of the paint and gives you more time to think. It is also ideal for softening the edges of washes and, when all else fails, a blast of the spray close to your paper will almost completely remove the paint. This should not be used as a general technique, only as a last resort. The spray must be able to create a fine mist rather than droplets. A firm push on the spray head is more likely to create a fine mist.

7 Kitchen paper

Apart from the obvious use of cleaning up spills or wiping out the palette, kitchen paper can be used to blot out wet colour from your painting. Again it is important not to get into the habit of overworking your painting and using this as a general technique.

GENERAL TECHNIQUES

PREPARING TO PAINT

Once you begin it is vital that everything you need is ready for use, and that you have transferred the outline onto your watercolour paper ready to paint. Each stage of a watercolour requires the wet paint to stay wet and any delay caused by something not being ready or accessible allows the paint to continue to dry. This stops the paint flowing and blending and causes unsightly marks. You can see from my set-up that everything is to hand: water, brushes and paint. I like to use an easel and most of what you can see has been made or adapted to make sure everything is ready to go. If you prefer to sit at a table, keep your paint, water and brushes to the right of your paper if you are right-handed and to the left if you are left-handed.

HOW TO HOLD YOUR BRUSH

As with most things in watercolour, a gentle touch is needed. Don't hold your brush in a vice-like grip – this inhibits flowing movement. Instead let it rest gently in your hand. I hold my brush so lightly that I often drop it, but that light touch leads to simple, flowing brush marks. Try to relax. I know this isn't easy, especially for a beginner, but successful watercolour depends on developing a relaxed physical approach. Your mind will probably be in a sheer panic – but don't tell your hand!

How to hold your brush.

How not to hold your brush.

ADDING WATER

Unlike traditional oil or acrylic painting, almost all watercolour paint must be mixed with water before applying it to the paper. This will give us a pool of colour that will run and blend – just what we want. Creating this pool of colour is not difficult, but the problem is that beginners often don't use either enough water or enough paint. In the projects, when I say to use a mix of particular colours, this always means to mix the paints in water, as shown here, unless stated otherwise.

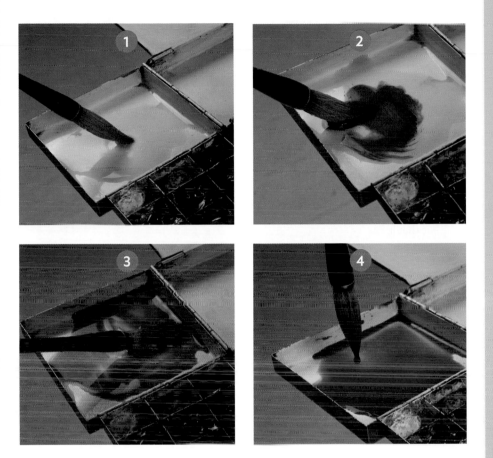

Grahame's top tip

Hopefully you have now got the idea of the full brush. Write yourself a reminder – in very large letters – at the top of your painting board. Many people get to this stage but then stroke their brush on the edge of the palette. What happens? This empties the brush. This is a habit that almost every painter develops and it is possibly down to getting confused between painting a picture and painting a kitchen wall. We don't want the paint to run on the wall but we do want it to run on the paper.

1 Transfer several brushloads of water from your water container to your mixing area. If you have too much for your immediate needs, don't worry, there will be plenty of opportunity to use it later in the painting.

2 Dip your brush into the paint you want to use and mix it with the water. Different paints have differing colour strengths so you will need to take account of this. Use more paint than you think looks right. A pool of colour will always look far darker than a thin layer on your paper. If it is really too strong, add more water.

3 Give it all a good mix. If little bits of pure paint remain in your brush, this will cause your wash to be uneven. But, having said that, many pieces of watercolour advice can be contradictory so here goes: if you are mixing two or more different colours, don't mix them together too much. A nice effect is created on the paper if a little of the original colours can be seen in the mixed colour.

4 For big washes, you must use a brush full of paint. Your brush should literally be dripping.

Grahame's top tip: how not to paint

This image shows me doing it all wrong. The wash will not be successful if it is applied too dry as the dried edges of the brushstrokes will be visible. There are only three ways you can paint with too dry a brush:

1 Your brush just isn't full enough. Please tell me you didn't wipe off excess paint on the edge of the palette.

2 You didn't dip in again soon enough. You must dip in once you see the bead disappear or at the end of the stroke, whichever happens first.

3 You press too hard with the brush on to the paper. Logic may suggest that if you press hard, more paint will be released but the opposite is the case – less paint is released and indeed this is one way of creating a drybrush effect.

Using too small a brush will make painting a wash a lot more difficult, simply because you will need many more brushstrokes, so try to use as big a brush as you feel comfortable with. In theory if we could use such a big brush that only one stroke was needed, every wash would be perfect!

CREATING A SMOOTH, WET WASH

For a smooth, wet wash the paint needs to flow. It can only flow if there is enough of it and if the paper is inclined at an angle of at least 25°. I paint at a steeper angle than this – about 45–50° – but I don't want you worrying about the paint running down the paper.

1 Using a full brush, paint a stroke from left to right (right to left if you are left-handed). You can see the bead of paint at the bottom of the stroke – this is your indication that you are painting wet enough.

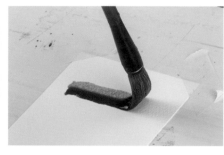

2 Dip in again to your pool of paint and paint another stroke, catching the bead from the previous stroke.

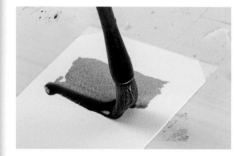

3 Repeat step 2 until the wash is completed. Repeat as before: dip, stroke, dip, stroke, dip, stroke.

4 When you have finished, you should have a wet bead from the final stroke. This must be removed, otherwise as it dries it will creep up the paper, causing a runback or cauliflower.

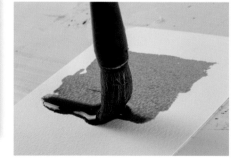

5 To dry up the bead, touch the tip of a barely damp brush to the bead. The bead of paint will be pulled into the brush.

6 This will leave you with a smooth wash with no sign of the edges of the brushstrokes.

CREATING A GRADUATED WASH

A graduated wash is where you are seeking to achieve a graduation of tone or value across the wash (light/dark) or where you are looking for a change in colour, or even a bit of both. In the examples below I demonstrate a smooth graduation from top to bottom, but the graduation could equally be side to side or even randomly distributed.

1 Start with a stroke of plain water and a smaller bead than with the plain wash. The smaller bead keeps the graduations more controllable but at the risk of premature drying, so don't delay.

2 Add a little French ultramarine to the pool of water in your palette and paint the next stroke.

3 Add a little more French ultramarine to the mix and continue with the next stroke.

4 Continue adding more French ultramarine to the mix and add the next stroke. Don't look for perfection. It is vitally important that you are not tempted to go back up, as this will ruin the wash.

5 The idea is for the wash to become imperceptibly darker with each stroke. A graduated wash is more difficult to paint than a flat wash because you need to control the flow down the paper.

6 Continue with the wash until you achieve the strength you are seeking.

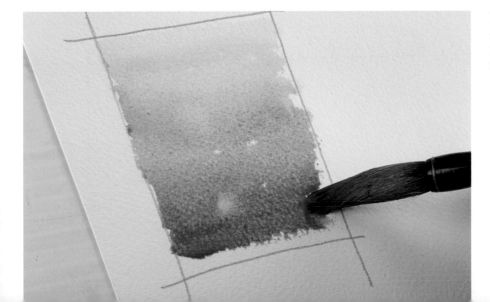

7 After the final stroke, soak up any bead with the tip of a just-damp brush and leave it to dry. Leaving things alone is so important. Don't fiddle unless you enjoy trying to fix mistakes.

MIXING COLOUR

In my palette I have nine permanent colours plus white. I use these colours irrespective of the subject or where it may be. From the muted colours of Ireland through to the sunny colours of Provence and on to the vibrancy of India, these nine colours do everything I need. Because there are only nine, I have come to know them well and I can instantly mix pretty much anything I need. That is the key. You must take time to play with your colours, to get to know them and to see what happens when they mix.

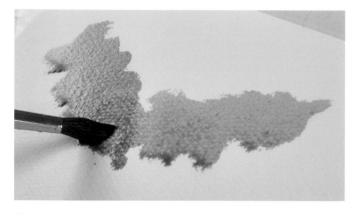

1 Mix quinacridone gold and phthalo blue (green shade). You can see the clear vibrant green that is produced when they blend. Actually the colours have more or less mixed themselves and this is down to how wet and mobile the colours are.

2 The three traditional primary colours are yellow, blue and red. Pyrrole (Winsor) red adds the third primary.

3 When a primary colour is mixed with its complementary secondary, both colours are greyed or dulled. You can see that the red and green (red's complementary secondary) are no longer as intense.

4 Magenta is a red that is biased towards blue. When mixed with yellow, the yellow cancels the blue bias, making it a more neutral primary red.

5 Because phthalo blue (green shade) is biased towards green, it can't make a vibrant purple when mixed with red.

6 Cadmium yellow and pyrrole red will mix to a decent orange because both pigments lean towards orange.

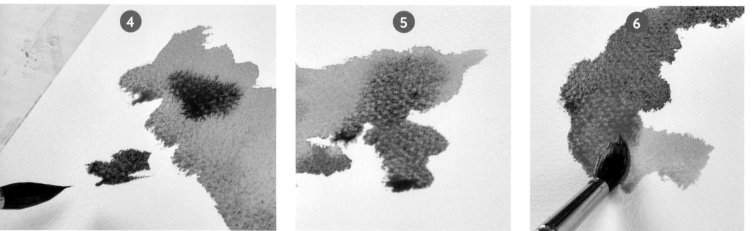

COLOUR BIASES

If your head has stopped spinning after the previous page we will look a little more at the importance of colour bias. Bias simply refers to the way a colour leans, so if you want to mix a bright purple (top mix, left), use a blue that has a hint of red (French ultramarine) and mix it with a red that has a hint of blue (quinacridone magenta).

If, on the other hand, you want a dull purple (bottom mix, left), take a blue that is biased towards yellow (phthalo blue (green shade)) and mix it with a red that is also biased towards yellow. Together they will produce a very dull, almost greyish purple. Dull colours are just as useful as bright colours but one of the common mistakes made by less-experienced painters is to paint everything with colours that are more at home in a rainbow.

FRAMING YOUR WORK

A watercolour must be framed behind glass and is best presented with what is known as a matte, which acts as a border and separates it from both the frame and the glass. Fashions come and go but at the time of writing, white frames with a white matte are probably the most popular for watercolours. Too narrow a matte does nothing for your painting. I would recommend at least 7cm (2¾in) for the paintings that come with this book. Poor framing will diminish even the best painting. A good professional framer will always be helpful with advice.

SHARING YOUR WORK

Today it is easy to share your paintings with the world. Just be aware that sharing publicly invites comments which may not always be complimentary so you may wish to restrict who can view your paintings. A constructive critic should always be welcome and if you have a partner or spouse you probably already have one!

Use masking tape to fix the paper.

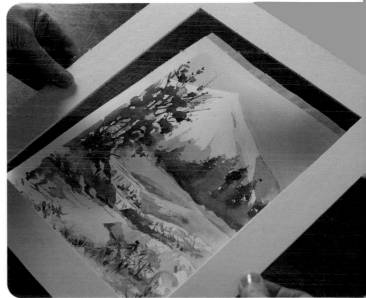

Add a ready-made frame over the top.

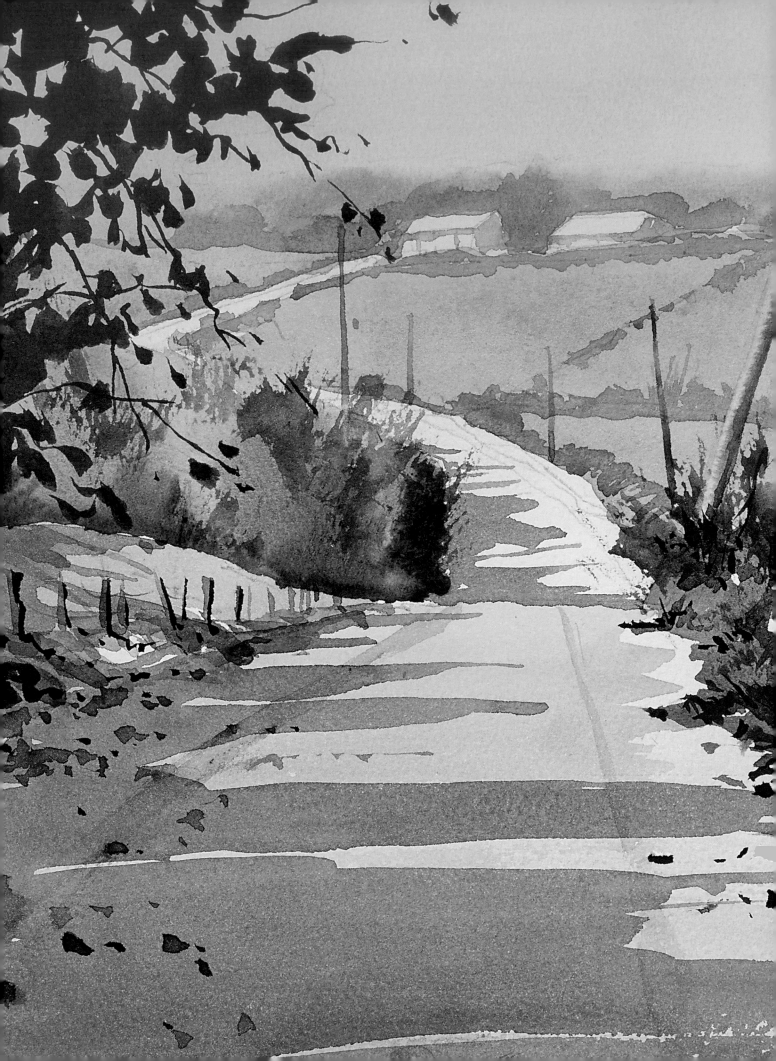

THE PROJECTS

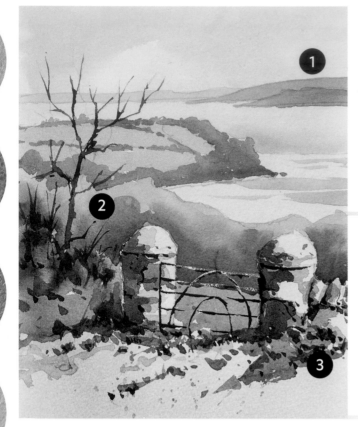

1. WINDMILL HILL

An elevated view gives us a good chance to practise techniques that help to convey a sense of depth. In the foreground, a gate and gateposts provide interest.

BEFORE YOU START

YOU WILL NEED
Wash brush, large, medium and small round brushes, sword liner, spray bottle, outline 1 (see page 98)

COLOURS NEEDED
Cobalt blue, French ultramarine, quinacridone gold, quinacridone magenta, burnt sienna, phthalo blue (green shade), white gouache

Technique 1: Aerial perspective

As the landscape recedes into the distance, the atmosphere causes colours to appear to weaken, often with a blue cast. In addition, details become less obvious, edges become softer and the tonal range reduces so that there will no longer be strong lights and darks. In short, everything becomes less obvious and more neutral. This effect can be used by the painter to suggest depth in what is, of course, a flat sheet of paper. Be aware that in reality the effect varies with the atmospheric conditions and is usually only really obvious at quite a distance. As painters we can and should exaggerate the effect if it will help the painting.

Grahame's top tip
Phthalo blue (green shade) is also known as intense, Winsor, phthalocyanine and monestial blue by different manufacturers, but these are all the same colour.

Here I have deliberately ignored the effect of aerial perspective. The distant landscape is a definite green with hints of detail, whereas the closest landscape is showing no detail and is quite a cool blue. Although we know instinctively which one is closest, there is a flatness to the subject.

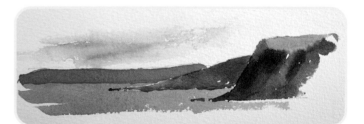

When aerial perspective is used, you can see that there is a much better impression of depth. One point to note is that in reality the blue section would probably not be so blue and we would probably be able to see detail and colour variations. In painting, it is important to simplify what we see. When deciding whether to go complex or simple, simple is almost always best.

Technique 2: Overlapping objects

While aerial perspective is a useful tool to help us suggest distance, overlapping shapes is an even better one. The principle is very simple: if a shape overlaps another shape then clearly it must be in front. When painting, try to include overlapping shapes and if they don't actually overlap then make them overlap. The spindly tree in this project (see the finished painting, opposite) wasn't actually there, but I put it in to help 'push back' the distant land masses.

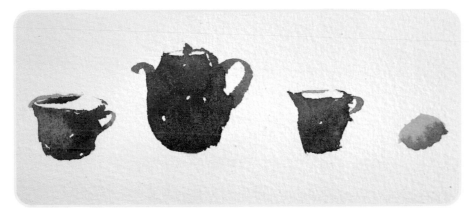

When the four objects are painted separately, it is virtually impossible to tell if one might be in front of another...

... but when the objects are overlapped it becomes quite clear. In addition, instead of four separate objects, we now have a group of four objects, creating a much more interesting single shape.

Technique 3: Connecting shapes

Following on from the previous technique is the idea of connections. In nature almost everything is physically connected to something else and so we need to see these connections in a painting. Beginners usually concentrate too much on painting individual objects, leaving them isolated and unnatural looking.

Grahame's top tip

Knowledge can often be a hindrance to a painting. Instead of painting what we know, we should instead paint what we see.

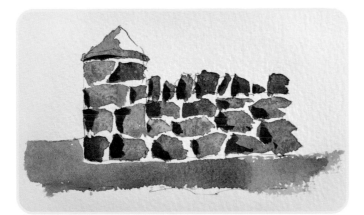

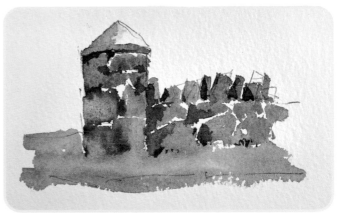

This is typical of how a beginner might paint the wall and grass and it is quite understandable. After all, we know that the wall is built from separate stones and we know that the grass is not physically part of the wall so why should they not all be separate objects in our painting?

The wall may be built from separate stones but once built it becomes a connected group of stones and this connected group of stones is physically connected to the grassy ground. The wall and grass is really one big, interesting single shape and so we should paint one big interesting shape.

THE PAINTING

1 Trace outline 1 on page 98 and transfer it onto your watercolour paper. Make sure that the paper is securely fixed to your board. Taping only the corners will be fine but taping all round creates a nice border.

2 A light spray of the paper increases the drying time of the subsequent washes. It should only be a light spray. The paper should not be wet – only barely damp. Wet a small natural sponge and squeeze it out ready for later.

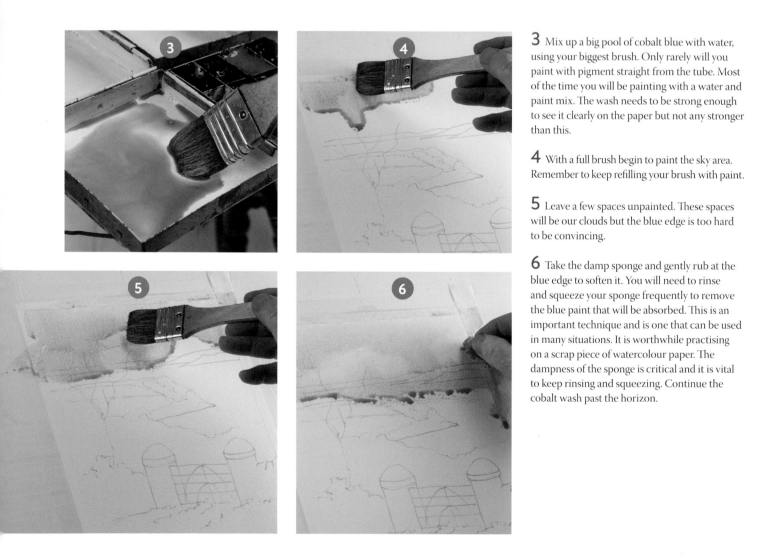

3 Mix up a big pool of cobalt blue with water, using your biggest brush. Only rarely will you paint with pigment straight from the tube. Most of the time you will be painting with a water and paint mix. The wash needs to be strong enough to see it clearly on the paper but not any stronger than this.

4 With a full brush begin to paint the sky area. Remember to keep refilling your brush with paint.

5 Leave a few spaces unpainted. These spaces will be our clouds but the blue edge is too hard to be convincing.

6 Take the damp sponge and gently rub at the blue edge to soften it. You will need to rinse and squeeze your sponge frequently to remove the blue paint that will be absorbed. This is an important technique and is one that can be used in many situations. It is worthwhile practising on a scrap piece of watercolour paper. The dampness of the sponge is critical and it is vital to keep rinsing and squeezing. Continue the cobalt wash past the horizon.

7 Continue the wet wash down the paper with a red/brown colour. It really isn't important what the actual colour is but I used quinacridone magenta with quinacridone gold mixed into the remnants of the cobalt blue wash in my palette.

8 Vary the colour as you go. This is burnt sienna, again added into the original wash in the palette, with a little water if needed. This method saves time by avoiding mixing completely new washes. It is more important that your first wash is continuous. This first wash will be your light in the final painting.

Grahame's top tip: working down

Start the wash at the top of your paper and work down. Never go back up even if the wash is not perfect. It is exceptionally difficult to fix a mistake in watercolour without creating a bigger mistake.

I make mistakes all the time and I rarely go back to fix them. On the occasions when I do... yes, I make them worse. By the end of the painting they've either fixed themselves (it does happen) or they're no longer important because the subsequent stages of the painting make them less obvious.

9 Continue to the bottom of your paper, dry the excess paint with the point of a damp brush and leave the wash to dry completely.

10 Now the wash is dry, change to your large round brush and mix up some new cobalt blue with a little burnt sienna to slightly grey the mix. If you still have a wash mix in your palette just add a little cobalt blue to this. Paint the most distant land mass in a single stroke if possible, but certainly without variation or detail. It should be stronger than the sky but still quite light. Allow to dry.

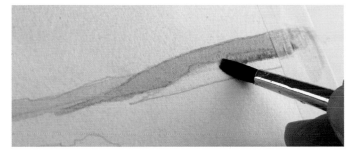

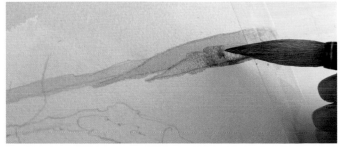

11 Add a little more cobalt blue along with a touch of quinacridone gold to the mix in your palette. Use this for the middle land mass. Because this will be stronger than the distant land it is better to soften the edge by removing excess watercolour where it overlaps the near land mass using a damp brush (see the tip on page 24). Allow to dry.

12 Paint the near land with the same wash but with a little more quinacridone gold. While this is still wet, drop in a couple of touches of a strong cobalt blue mix to create variety.

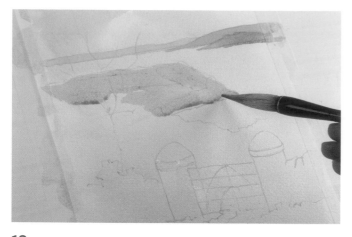

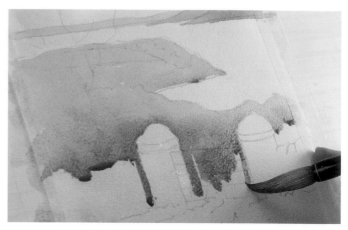

13 Use the mix from step 12 (cobalt blue, burnt sienna and quinacridone gold) to begin the foreground mix. Do not paint around the tree. This is fiddly and unnecessary. The tree is darker than the background and so can be painted over it later.

14 Continue down with the wash, adding more quinacridone gold as you go. Paint around the gateposts. These are big simple shapes that are easy to paint around and we will need to reserve at least some of the light that is on them.

Grahame's top tip: removing excess watercolour

It is vital to dry up any little excess drips that will occur as you paint. If these are left, the area around each drip will start to dry and the drip will start to creep into the dried area, creating a broken edge known as a runback or cauliflower. These runbacks can be useful on occasion, but their effect on the painting is unpredictable. Rinse your brush, squeeze it almost dry and touch it to the drip, which will be pulled into the brush. You don't need to touch the paper, just the drip.

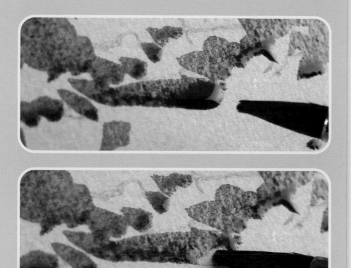

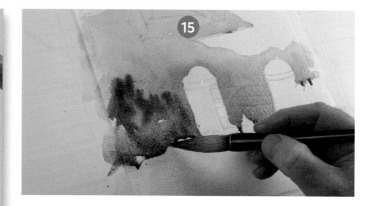

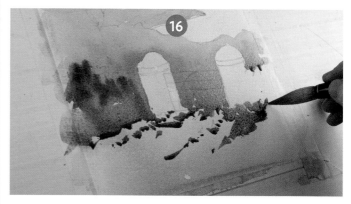

15 Some French ultramarine might be useful to separate the hedge from the background hills. If you find that it looks rather too strong it's not a serious mistake. Better to leave it rather than 'fix' it into a serious mistake!

16 Adding a little quinacridone gold, continue down the paper and hint at a few tufts of grass. This is intended to look as if the grass is petering out into the roadway. Relax while the paint dries.

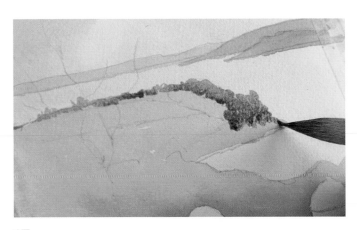

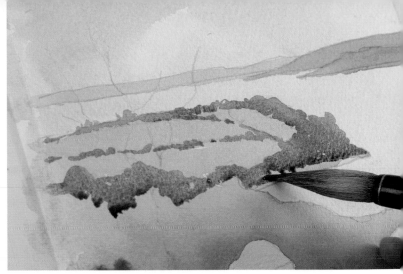

17 Using French ultramarine with quinacridone gold rather than cobalt blue will result in a warmer green that is better for foregrounds. Use this to paint the trees and hedgerows on the hill.

18 Don't mix the two colours completely. You can see how some parts of the hedgerows are bluer or more yellow than others. This is a simple way to create variety in the greens while still painting them as a single mass.

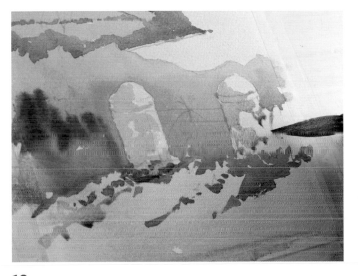

19 Burnt sienna mixed with a little French ultramarine results in a brown grey which can be used to begin the gateposts and wall. At this point you will not know how strong or varied this area needs to be so play safe and keep fairly light. It is a lot easier to add paint than to take it away!

Grahame's top tip: splattering

Splattering is great fun but can be messy so beware. The size of the splattered drops will vary with the size of the brush. I am using my size 7 here and the brush is full of wash. Holding the brush firmly between my thumb and middle finger, I sharply tap my index finger on to the ferrule of the brush. This should give a nice spray of splatter that is useful to suggest leaves on trees or even just to create a little random variety. This is a seemingly very simple technique but it does need practice. Many people find it difficult at first to hold the brush firmly enough while tapping it.

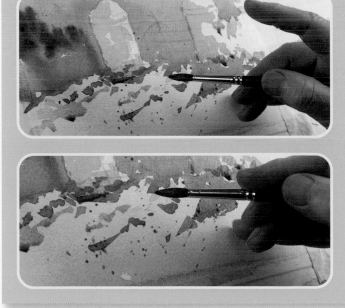

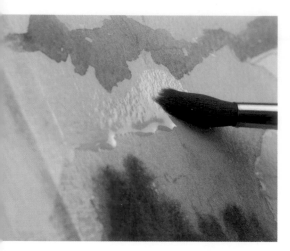

20 Change down to your medium (size 10) brush. You want to suggest some hedging at the far end of the field, so you need to darken that area. You want it to gradually darken the hedge from the top down, so first apply some plain water to the top of the hedge.

21 Paint a fairly strong French ultramarine/quinacridone gold mix into the water, followed by the same mix, but with more pigment in order to gradually darken the lower part of the hedge.

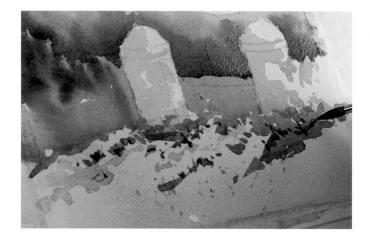

22 As there is still some of the dark green mix left, add a few tufts of grass in front of the gate.

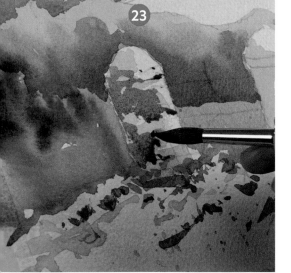

23 The gateposts need to be darkened at the left sides. Again, use your trusty burnt sienna/French ultramarine mix to cover some, but not all, of that first partial wash.

24 There are now three different tones on this area, which creates variety and variety is always welcome.

25 Use your sword liner brush and a very strong French ultramarine/burnt sienna mix to paint the sapling. Use little, jerky movements to achieve the angularity of the twigs rather than smooth, curvy strokes.

26 Always paint trees from the top down. If you paint from the bottom up which may seem more logical, your wash would run back down over the areas you had just painted. Although not so important with a small sapling, it is an essential consideration for the bigger trees we will be painting later.

27 To prevent the sapling from looking too isolated, include other shoots and twigs growing from the hedge.

28 Allow some of the shoots and twigs to blend with the hedge, using the connecting shapes technique we discussed earlier (see page 21).

29 Add a few more touches of the brush to hint at the variety of grass at the bottom of the hedge and in front of the gate.

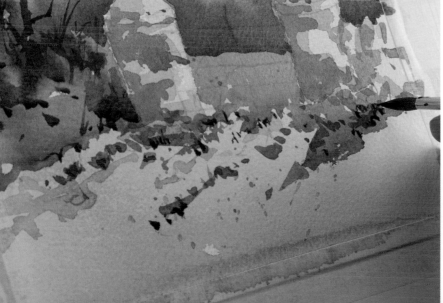

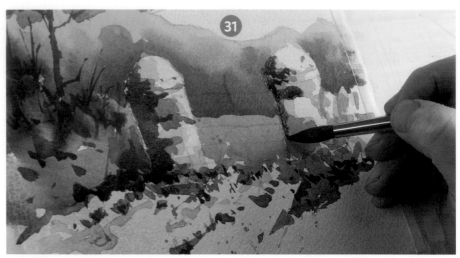

30 Time for some shadows. I like to use a purple/grey mix for shadows and here I mix French ultramarine with pyrrole red. This gives slightly too purple a mix, but a tiny amount of phthalo blue (green shade) soon greys it. Phthalo blue (green shade) is an exceptionally strong pigment: a little goes a long way.

31 Shadows need to be applied simply and in one go to be effective. It is important that you don't go over them more than once.

32 Try to link shadow areas together, once again on the principle that one big interesting shape is better than a lot of small, less interesting shapes.

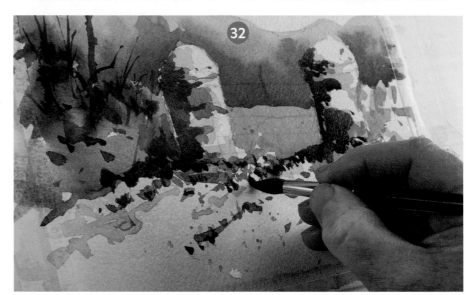

33 The sea needs a little more variety. The more distant part should be softer, so begin by wetting that area with water.

34 Paint a cobalt blue mix into the wet area and paint down. This gives a soft edge at the top and a hard edge at the bottom.

35 Meander down the paper adding little blue strokes, painting each one slightly differently. Remember that this is the background, so we don't want to make it so interesting that it 'comes forward'.

36 On second thoughts, the hardness of the bottom of that first stroke at step 34 looks too hard, so soften it with a damp brush. In watercolour, softening has much the same effect as erasing a pencil line.

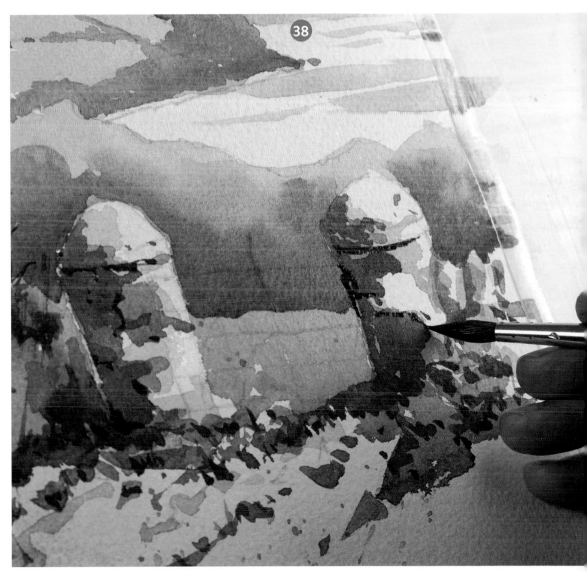

37 Can you see how stiff this mix is? It is basically French ultramarine and burnt sienna straight from the tubes with literally only a touch of water. It should feel slightly sticky under the brush and it should be a rich dark, almost black.

38 Your final touches in a watercolour should always be with this rich dark because the strong darks make the area around them appear to be relatively lighter. Little flicks of dark here and there have the effect of adding light.

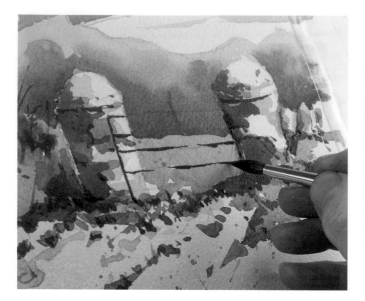

39 Use the same dark colour to paint the parts of the gate that have a light background.

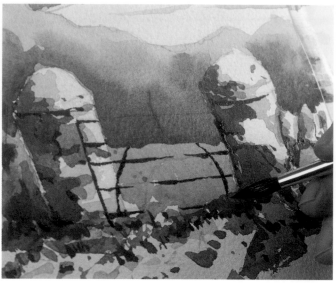

40 Broken lines for the gate structure look more natural. This sounds odd, but perfectly straight lines or, for that matter, perfect geometric shapes catch the eye too much.

Grahame's top tip: using gouache for highlights

The big drawback with watercolour is that you can't paint light over dark. When you need to have a light area in front of a dark, you have only four options. You can paint around the light; you can lift the light out; you can use masking fluid or you can use white gouache. For small highlights I believe that gouache offers the best result. As long as you use it with no more than a touch of water, you get a perfect white broken line that sits nicely with the rest of the painting, so much so that it should not be obvious that gouache has been used. If pure white is too stark, you can mix in a touch of any of your colours.

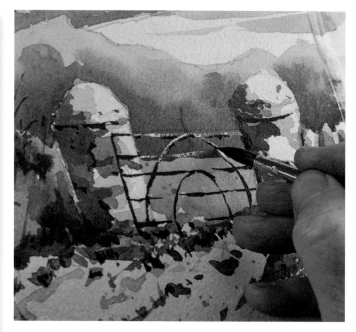

41 White gouache is used for those parts of the gate that have dark behind them. Again, this sounds odd but it works! Always look for opportunities to develop light against dark and dark against light.

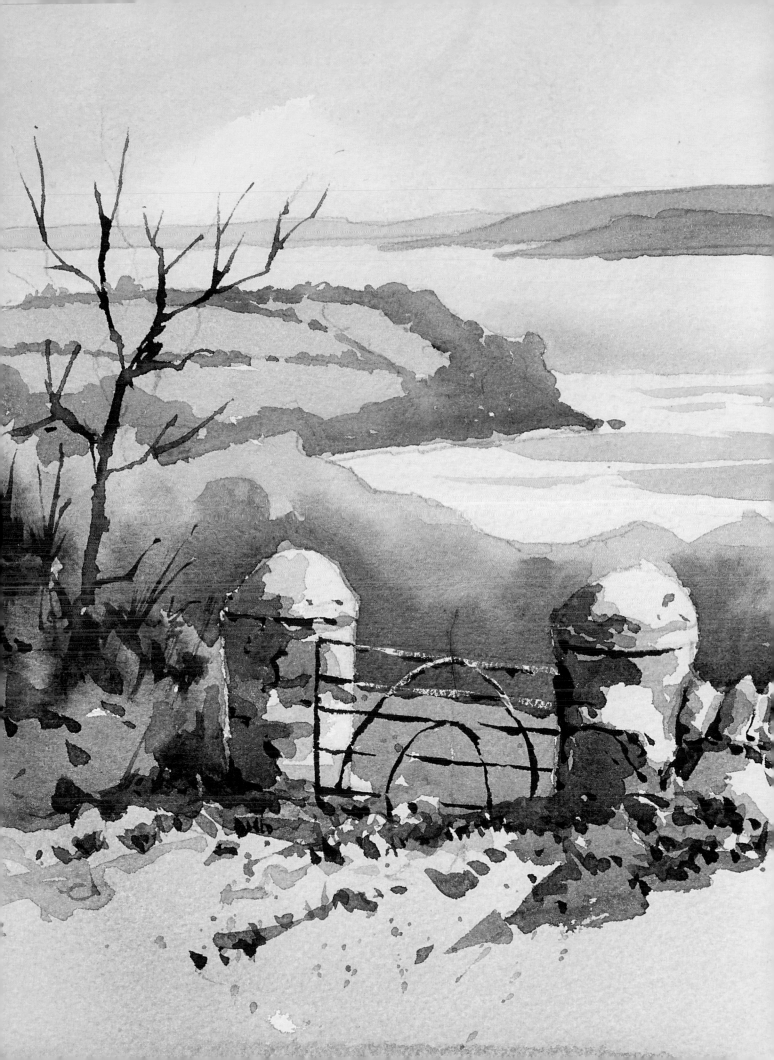

2. MOUNTAIN ROAD

A road through the mountains meanders up and down, giving us the opportunity to create the illusion of the road rising and falling, as well as lots of overlapping shapes.

BEFORE YOU START

YOU WILL NEED
Wash brush, large, medium and small round brushes, sword liner, outline 2 (see page 99)

COLOURS NEEDED
Cobalt, French ultramarine, phthalo blue (green shade), quinacridone gold, quinacridone magenta, burnt sienna

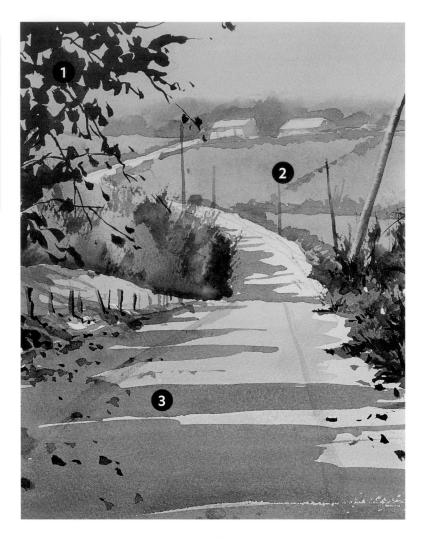

Technique 1: Painting convincing silhouettes

Silhouettes are really useful in the foreground of landscape paintings where they can create an effective frame to the rest of the subject. They must be so dark that we don't expect to see detail, so they are straightforward to paint with just a flat, dark wash.

For a silhouette to be effective it must be dark – very dark. If it is painted too light, as I have done below left, it simply blends into the other vegetation with absolutely no sense of being in the foreground. The other issue with it not being dark enough is that we can see the background trees through the silhouette: something that clearly could not happen.

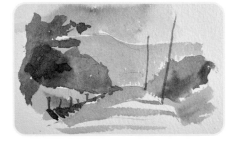

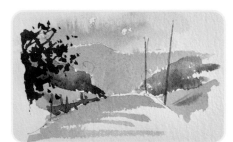

A good mix for a very dark silhouette is phthalo blue (green shade) mixed with burnt sienna. You will need more of the burnt sienna, but the intensity of the phthalo blue (green shade) allows you to mix a really dark but mobile green. Apply the paint quickly and simply, don't overpaint areas you have already painted and try for very uneven edges.

Technique 2: Creating variety in repeating objects

Many subjects have a number of repeating objects in them. Even if in reality every one is exactly the same, to paint them in this way gives a boring result. Instead, try to vary each one slightly. This is much more interesting to the eye.

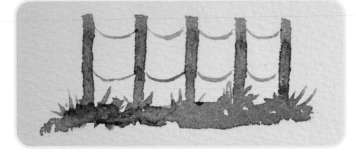

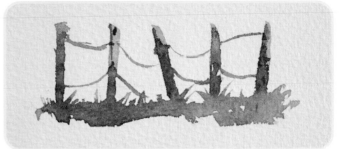

Here we have a row of five fence posts, each one exactly the same tone, size and colour and connecting to the next post with two little arcs of wire. Imagine a whole line of such posts... How boring to look at! For a painting to be interesting, the paint must have exciting shapes, colours and tones.

This is more like it. Each post has been painted in a slightly different way using a variety of colour and tone. They don't all stand perfectly straight and the wire between each post follows a slightly different route. The farmer may not be too happy, but isn't this much more interesting?

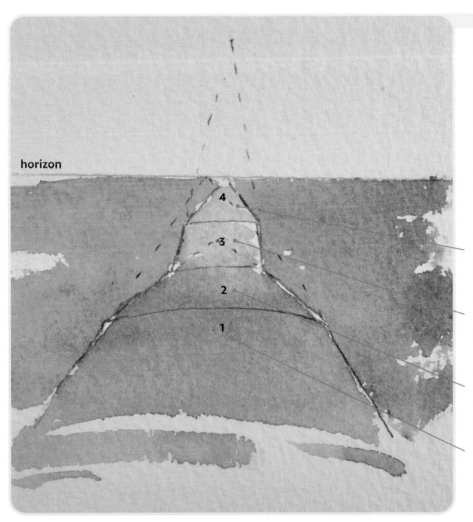

Technique 3: Creating perspective on a mountain road

The standard rule of perspective states that 'receding, horizontal, parallel lines appear to slope towards the horizon and meet at a single point'. This allows us to create things like rivers and level roads. Things get a little more complicated when the roads go up or down.

This is the horizon and you can see how the two flat sections of the road (1 and 4) meet here when continued.

When continued, the edges of this part of the road (3) meet above the horizon, indicating that the road is going uphill.

This part of the road (2) is going downhill and will therefore meet below the horizon when continued.

Most roads are cambered – they have a slight upward curve from edge to edge to allow water to drain off. This can be indicated simply by painting the road with a slight upward curve rather than perfectly horizontally.

THE PAINTING

1 Trace outline 2 on page 99 and transfer it onto watercolour paper. The advantage of a taped border is that when the tape is removed, the painting will appear to continue beyond it, but only if you paint right over the tape – don't leave a gap between your painting and the tape.

2 Again, use your wash brush and cobalt blue for the sky area. Because the sky area is a relatively small part of the painting there is no need to add clouds as they could distract from the rest of the painting. Remember, paint top to bottom and notice the nice drippy edge – keep that brush loaded!

4 Adding a little quinacridone gold will green the mix in this area of vegetation.

5 Finally, add a little more quinacridone magenta as the wash continues down to the road. This is just for variety. Feel free to use your own colour mix.

3 At the bottom of the sky add a little quinacridone magenta to your mix to vary the colour, but do not stop or leave a space for anything.

6 The first wash is finished but make sure that you dry up the bead of paint at the bottom. If there is no bead of paint to dry, you are not painting wet enough. Leave to dry.

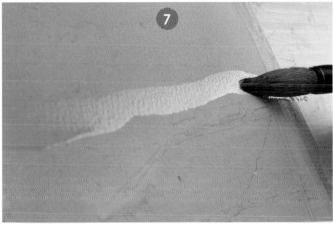

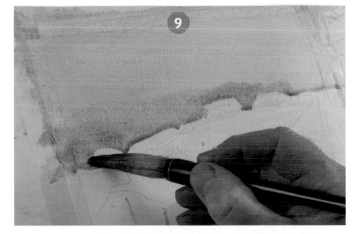

7 A slightly soft edge will make the distant hills appear to be further away, so begin by gently wetting the area with your large round brush.

8 Using a mix of cobalt blue with quinacridone gold, paint into the lower part of the wetted area. This will allow the paint to drift up, so creating the soft edge.

9 Continue this wash down to and around the distant buildings.

10 The edge from step 8 has not softened as much as it could have, so soften it a little more using a barely damp brush. The risk here is that if your brush is too wet, water will flow from it and create a runback. If this happens, leave it alone. Allow to dry.

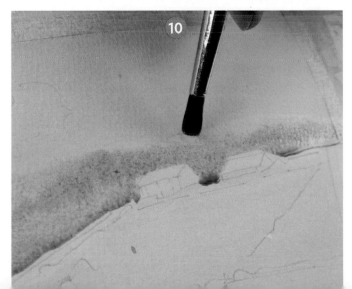

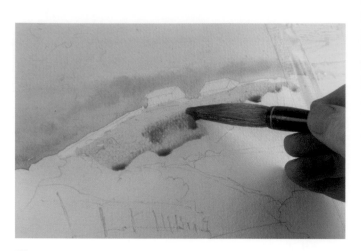

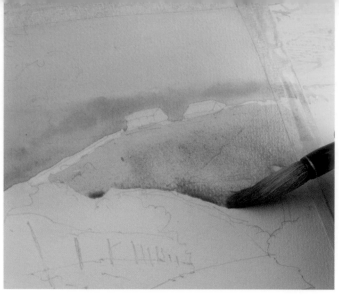

11 Leaving a gap for the buildings and distant hedge, start the fields with a warmer green mixed from French ultramarine and quinacridone gold.

12 Continue down and create variety by mixing some of the paint on the paper itself so that some parts are more blue while other parts are more yellow.

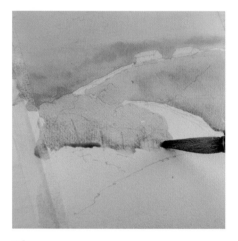

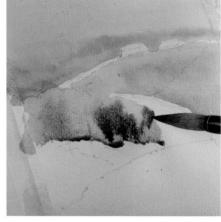

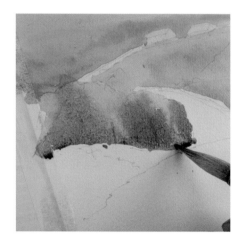

13 Connect this wash into the nearer field but leave most of the road untouched.

14 While the wash is still wet, drop in a stronger mix of the same pigments. This should look a little too dark.

15 Notice how the darker paint drifts through the wet wash becoming lighter as it goes. If you find that your darker wash simply disappears, don't worry, just repeat it while everything is still wet.

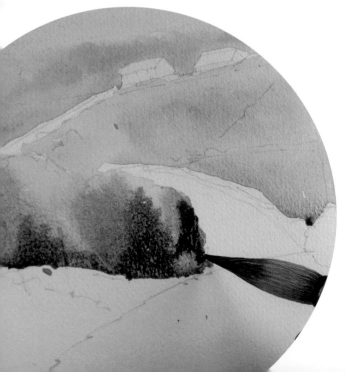

16 Drop in a stronger wash again to suggest a little variety in the middle-distance trees. It is important to allow the wash to dry at this stage.

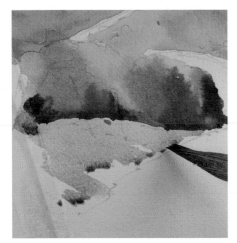

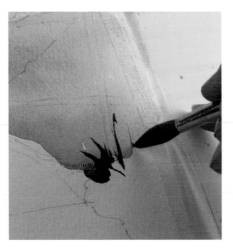

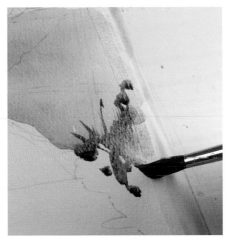

17 Now paint the near field, again with French ultramarine and quinacridone gold. The hard edge between the field and the bottom of the trees is intended to suggest a slightly hilly field. The suggestion is that the field continues beyond the top edge and so we can't see where it meets the trees. There is no physical connection and so we use a hard edge. If we could see where the trees meet the field, a soft edge would have been used because there would have been a physical connection.

18 Switching to your medium brush, a few simple upward-sweeping strokes begins the process of hinting at the shrubs in that area.

19 At this stage your strokes should only be hinting at and suggesting fields and shrubs – deliberately avoiding detail. Any detail should be saved for the end.

20 Again, vary the wash and finish with a few little horizontal strokes at the edge of the road. Directional strokes will describe the structure of what you are painting. Upward strokes describe the tree and horizontal strokes describe the grass extending on to the flat road.

21 Going back to your large brush, use gently upward-curving strokes with a wash of cobalt blue to suggest the road camber where the road dips out of sight.

22 Add a little burnt sienna to the mix to warm the road up as it approaches the foreground.

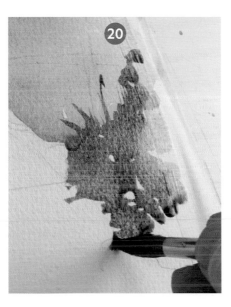

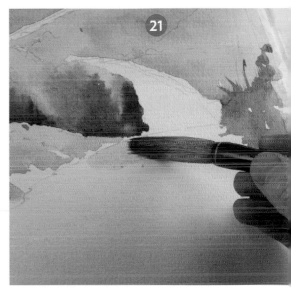

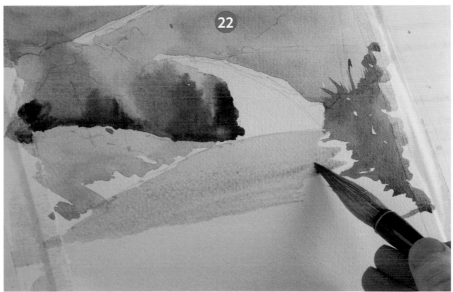

23 As you approach the bottom of the paper, use the side of the brush to give a few drybrush strokes.

24 With a little more burnt sienna, continue with slightly stronger drybrush marks. A brush is designed to release paint from the tip. It doesn't do a great job of releasing it from the side – perfect for broken drybrush effects. Allow to dry.

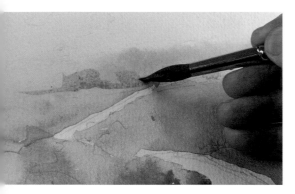

25 Using your medium brush, go back up to the far distance and paint a hint of trees growing behind the buildings using a bluish mix of cobalt blue and quinacridone gold.

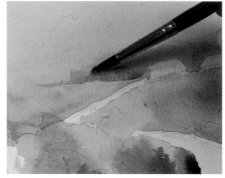

26 Avoid a completely hard edge here. Although the tops of the trees are not connected to the land behind which would suggest a hard edge, the effects of aerial perspective would be seen as a partial softening of this edge. Use a slightly damp (not wet) brush to do the softening.

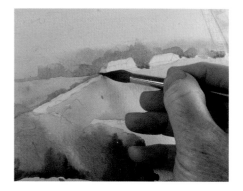

27 When you are painting the trees, you are also painting the edge of the buildings. This must be done carefully and accurately to give the impression of the trees disappearing behind the buildings.

Grahame's top tip: creating distant buildings

If we follow through the idea of aerial perspective, then we must avoid detail in distant buildings – but how can we show the three-dimensional structure and yet keep it simple? If you use a simple continuous blue/grey wash for shadows on the side of the building and underneath the front eaves, just pull down a couple of vertical lines from the wet shadow and these will read as windows. Once again we paint a single connecting shape rather than three or four separated shapes.

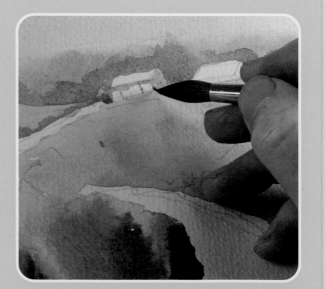

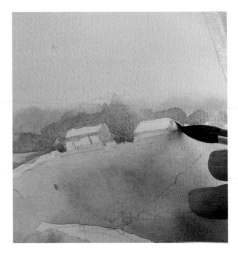

28 Use quite a weak cobalt blue and burnt sienna wash for the building shadows. Don't be tempted to paint window panes or pots of flowers or chickens. These buildings are too far away for detail to be evident.

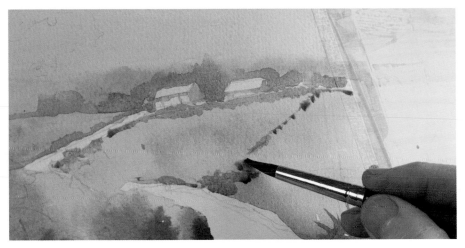

29 Adding a touch of quinacridone gold in the mix greens it up a little. Paint the hedgerows with a broken uneven line.

30 Add a little more quinacridone gold and continue along the side of the road.

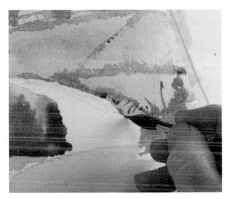

31 Break up the wash a little, using curved strokes to describe the shape of the hedge.

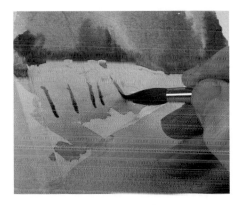

32 Use French ultramarine and burnt sienna to paint the fence posts. Remember, don't make them all perfectly vertical as if the fence was just built. Let some of them lean slightly.

33 While the posts are still wet, drop a little French ultramarine into one or two of them to create variety and interest.

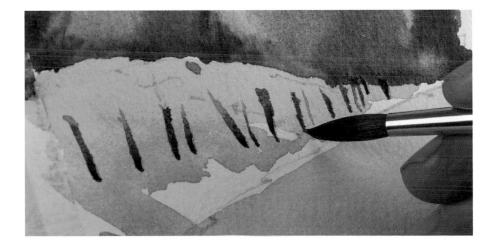

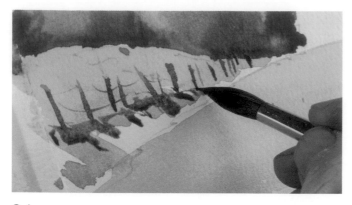

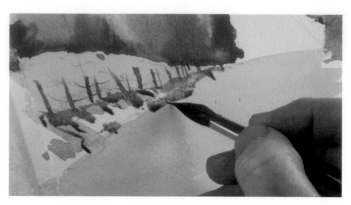

34 Use the French ultramarine and quinacridone gold mix to suggest grass, but really to connect the bottoms of the posts to produce one connecting shape.

35 Bring the grass down to the bottom of the bank but leave some spaces in the bank. It is best not to completely cover a previous wash. Each time you paint over a previous wash you are reducing the amount of light that will be there at the end.

Grahame's top tip: creating variety in the middle ground

In general the distance should have little or no detail and the foreground, because it is closer, will often have the greatest amount of detail but what about the area in between? Here we need a little detail but not too much (this is starting to sound like Goldilocks) and in landscapes the side of your brush is a perfect tool for this. The dragged drybrush marks produced are perfect to suggest detail without being too specific.

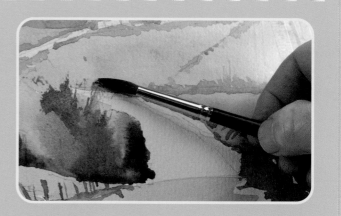

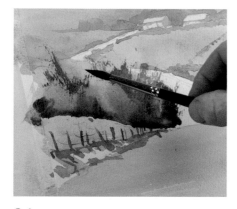

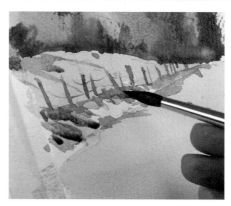

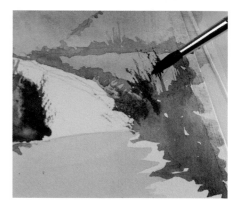

36 Use the side of the brush to create the illusion of the middle-distance shrubs. The precise colour is not too important but the usual green mix of French ultramarine and quinacridone gold will suit, perhaps with a little burnt sienna for variation.

37 The foreground field and bank are a little bland and need a few strokes of a brighter green made from French ultramarine and quinacridone gold plus a tiny amount of phthalo blue (green shade). Remember to paint these strokes in a direction that describes the slope of the ground.

38 Now turn your attention to the close foreground. Using the same mix, add some drybrush marks with the side of the brush.

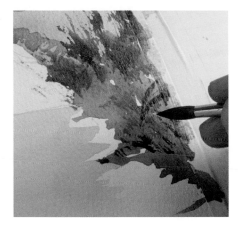

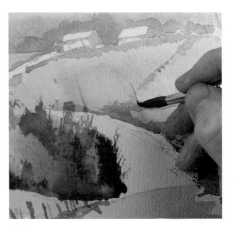

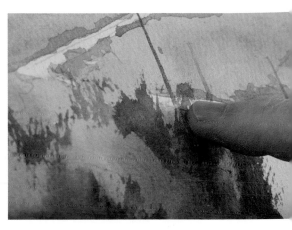

39 Follow these up with just a few definite flicks of the brush to suggest grass.

40 The telegraph poles are useful to add a sense of depth that is indicated by their diminishing size. Paint the first couple of distant poles quite pale with no variation in colour or tone.

41 Use the tip of your finger to blend the telegraph pole into the hedge.

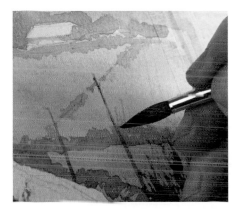

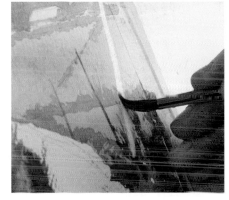

42 As you get closer, vary the colour and tone.

43 Space for the large telegraph pole is lifted out from the background.

Grahame's top tip: lifting out colour

The results of attempting to paint round something long and thin are rarely satisfactory, especially if the background is very complex. It is much easier and better to ignore the telegraph pole and lift out the background colour later. Simply paint the pole area with plain water, leave for ten to fifteen seconds and then gently scrub with a damp brush. A paper towel pressed on the damp lifted area should lift almost all of the remaining colour out. Some papers are more difficult to lift paint from than others.

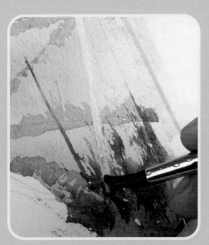

44 Quickly paint a line of a dark mix of French ultramarine and burnt sienna down the right side of the pole.

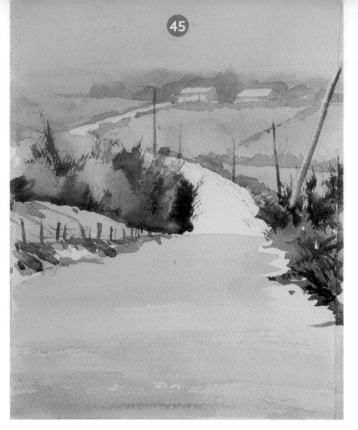

45 Before the line dries, run a slightly wet brush down the left side, allowing it to touch the dark line. This will allow the dark colour to drift across to the light side giving a gentle light to dark transition which is what you see on a cylinder. If the dark paint does not drift across you have either allowed it to dry, you haven't quite touched the edge of the dark or your brush isn't wet enough. This is another technique that benefits from practice.

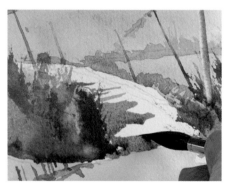

46 Shadows next. Remember to mix plenty of shadow mix: French ultramarine, quinacridone magenta and a touch of phthalo blue (green shade). Starting up the road paint some shadow marks on the left side of the road. Make the marks uneven to suggest the uneven vegetation that is casting the shadows.

47 It is vital to keep moving down and to avoid the temptation to go back up.

48 As the shadows come closer they will appear to get bigger: one of the effects of perspective. Stop the road shadow where the road dips down the hill. This helps to make this break in the road more obvious.

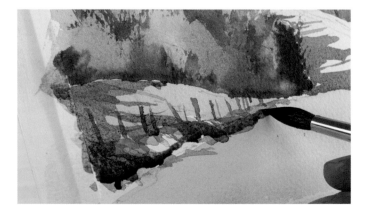

49 Don't restrict the shadows to the roadway. Paint them everywhere you would expect shadows to be cast. The darkness of shadows is a great way to bring tonal contrast into your painting.

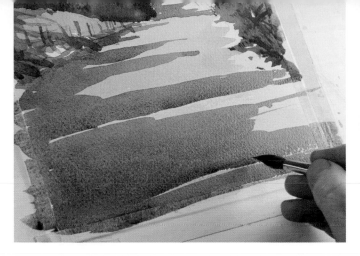

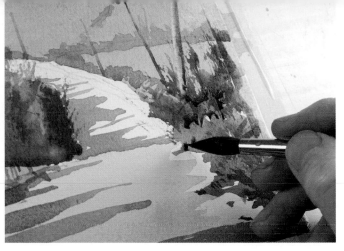

50 Then continue the shadow across the closest part of the road. Make sure your brush is really full for this. Stripes in the dried shadow is not a good look!

51 Finish off the shadows with a few strokes in the right-hand hedgerow.

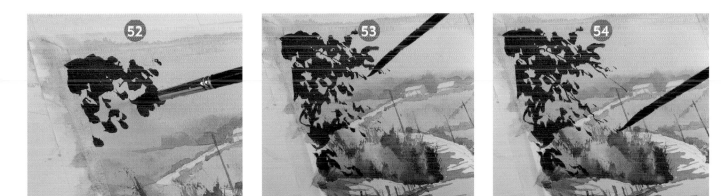

Grahame's top tip: creating organic leaf shapes

You may think that dabbing the brush on to the paper would be a good way of creating leaves but unfortunately this results in obvious repetitive marks. 'But surely leaves are all the same', I hear you cry. To a certain extent this is true, but in a tree we do not see thousands of individual leaves, we see a group of leaves and the blending of the thousands of leaves instead gives us an extremely varied array of shapes, connected with twigs. This needs a bit of practice. We are all programmed to be quite tidy (possibly except for my daughters) and there is a tendency not to create enough variety.

52 Using a strong mix of phthalo blue (green shade) and burnt sienna, apply the paint as randomly as you can. Try to avoid any hint of a straight line or geometric shape.

53 Once you have completed a few shapes, use the same mix and the sword liner to link them with twigs.

54 It is fine to extend some of the twigs beyond the bunches of leaves.

55 It is also desirable to paint a few solitary leaves, not connected to anything else. This works because in reality we would not be aware of the tiny twigs connecting to the outermost leaves.

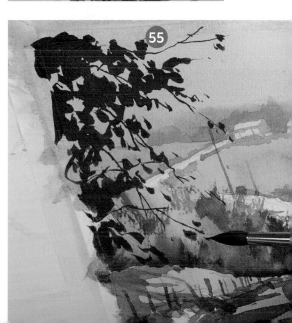

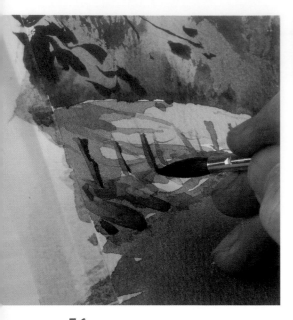

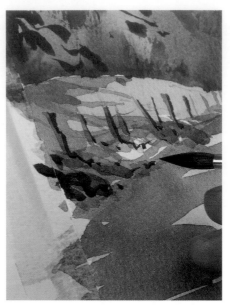

56 It is now time for the final darks. Start with the obvious places such as the shadow side of the posts.

57 However, don't be afraid to add some darks in an almost random way.

58 Adding these little darks to lighter areas produces the same sparkle as adding light to dark areas.

59 Add a few touches of a burnt sienna mix to suggest fallen leaves.

60 Finally, pick up some of the greyish dregs of paint in your palette and add a couple of vague lines on the road. As well as mimicking the natural wear on a road these lines help to draw the eye into the painting.

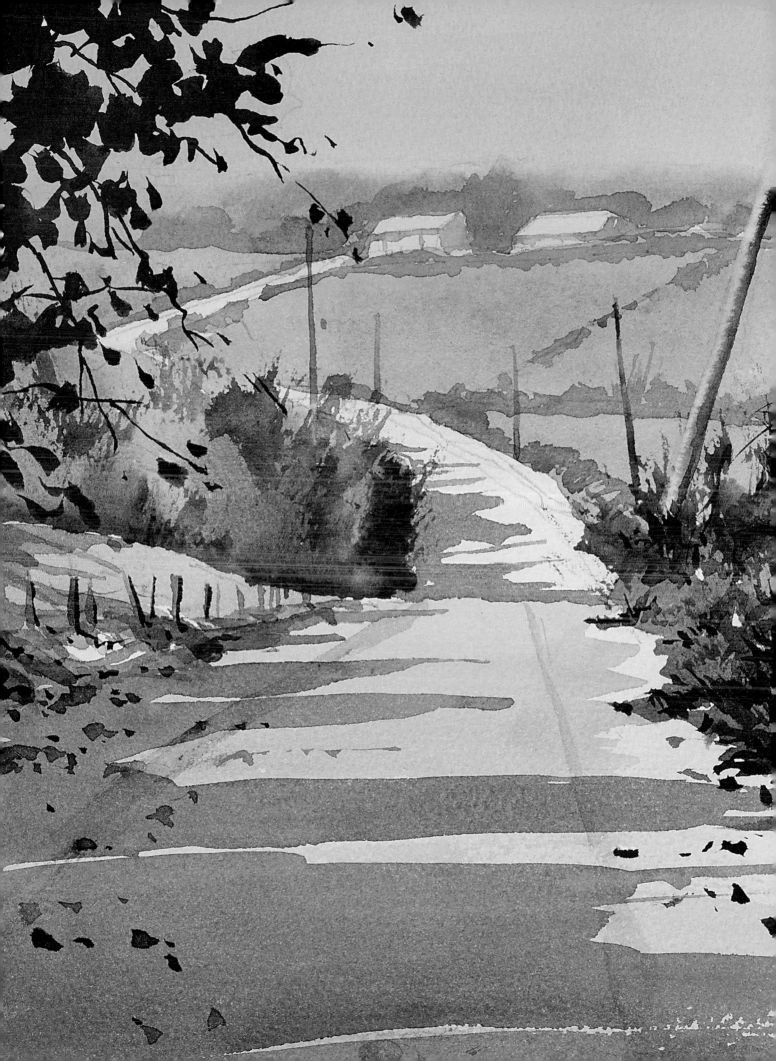

3. RIVER AND BRIDGE

Rivers are great subjects for landscape paintings and here I have included an old bridge as well as a variety of young and mature broadleaf trees.

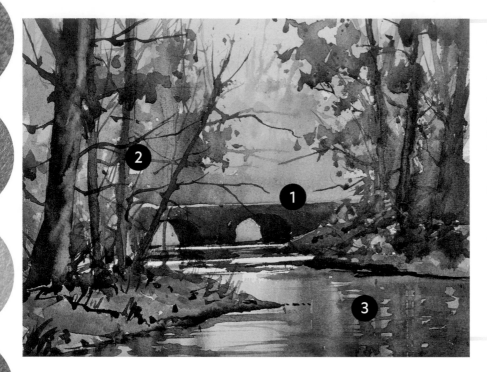

BEFORE YOU START

YOU WILL NEED

Wash brush, large, medium and small round brushes, sword liner, spray bottle, outline 3 (see page 100)

COLOURS NEEDED

French ultramarine, cobalt blue, phthalo blue (green shade), quinacridone gold, quinacridone magenta, pyrrole (Winsor) red, burnt sienna

Technique 1: Simplifying shapes

Everything can be constructed from simple geometric shapes such as spheres, cubes, pyramids, cones and cylinders. Even the most complex construction can be reduced to these simple components. A skyscraper is really no more difficult to draw than a cottage – it just has more windows.

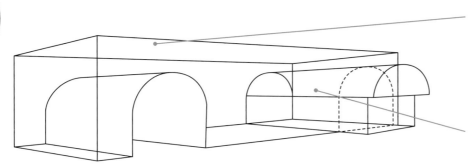

Our bridge is basically a long box with cutouts for the arches. More complex bridges may have parapets and other variations, but these too can be reduced to simple shapes.

Think of each arch as a box with a half cylinder on top. Thinking in terms of simple shapes and how they interact should make constructing a drawing less daunting.

Technique 2: Creating trees at different distances

To paint natural-looking receding trees we must again think of the effects of aerial perspective. As the trees recede they will appear to be less varied in detail, colour and tone.

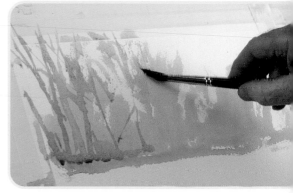

1 Start with a simple broken wash of cobalt blue. Use your medium brush on its side for this. The idea is to create nothing more than the rough shape of a group of distant trees – no leaves or branches. Leave about one third of the paper at the bottom untouched as you will use it for the next technique. Allow to dry.

2 Using the same wash but slightly stronger, paint some flat tree shapes. Vary the colour of the wash with a little quinacridone gold and allow all of the tree shapes to interconnect. This wash suggests the middle ground trees.

3 A little drybrush from the side of the brush hints at twigs and leaves but again this is allowed to blend with the other strokes.

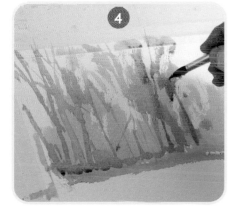

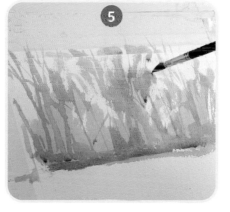

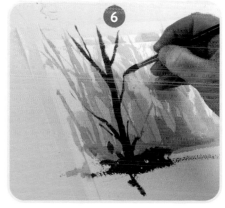

4 Continue to work across the paper. Vary the trunks by making some thicker and some thinner and allow one or two of the trees to lean. Repetition with variation is the key.

5 When you get to the other side of the paper, leave it alone and allow to dry. Don't be tempted to add detail. You have now painted your middle-ground trees.

6 There are a couple of ways to paint foreground trees. Paint the first tree with a strong wash of French ultramarine and burnt sienna and allow it to dry.

7 When dry, gently scrub some light from the right side of the tree. The soft lifted-out line will suggest the cylindrical shape of the tree.

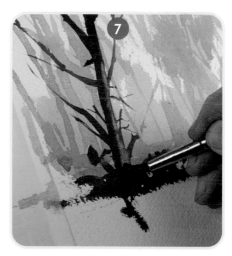

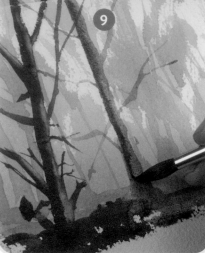

8 For the next tree, use a medium wash of French ultramarine and burnt sienna. Do not allow to dry.

9 Immediately paint a stronger line of the previous mix down the left side of the tree. This time the dark should drift across into the light, again hinting at the cylindrical shape. It is important to join the trees together at their bases. This connects them to the ground and to each other.

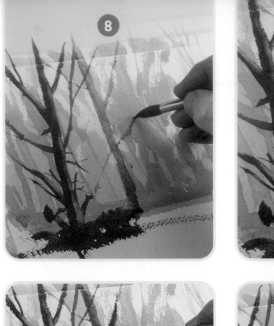

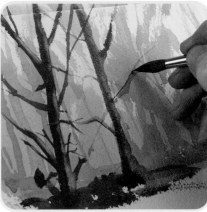

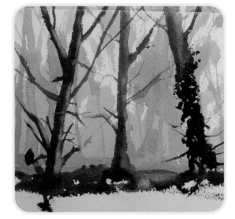

10 Side branches are best painted while the main trunk is still wet so that they softly link.

11 Ivy can be simply suggested with a dark green mix (burnt sienna and phthalo blue (green shade)) painted roughly and unevenly on to the trunk.

Technique 3: Reflections

There are probably as many ways of painting reflections as there are types of reflections, but in general using vertical strokes to suggest the reflections along with horizontal strokes to suggest the surface of the river works well.

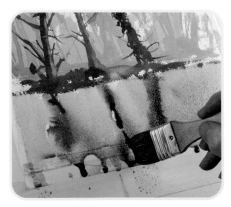

1 Painted reflections are best done with vertical strokes. Ripples in the water cause reflections to be elongated and blurred.

2 Work across the paper, changing the strength of the vertical strokes as you go. Colour isn't too important, but most of the strokes shown are variations of the French ultramarine and burnt sienna mix.

3 Use your brush to gently encourage the flow down the paper, but make sure each stroke blends into the next.

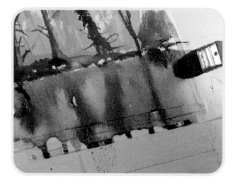

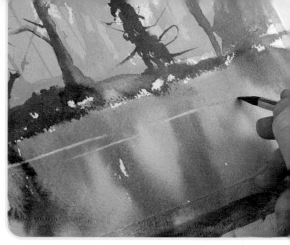

4 Continue across to the other side of the paper. The idea is to create a barcode type of appearance – darks and lights of varying width.

5 This is my old worn sable that I use for lifting out. If I squeeze it I can get a perfect thin edge. If you don't have a fifty-year-old sable lying around, a small flat brush would work equally well.

6 Using the damp thin edge, lift out a few horizontal lines. This is easier to do while the previous wash is still damp but not wet.

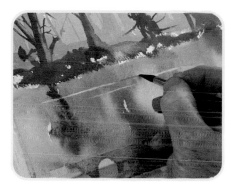
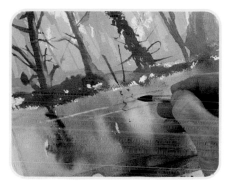
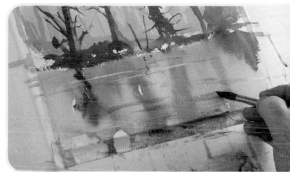

7 Add some dark lines with your small round brush. It makes sense to lift out the light lines from dark areas and to paint dark lines over lighter areas.

8 The effect of the reflections is increased if you add a few definite directional strokes, maybe suggesting posts or tall grass and adding the reflection with a squiggly line. Remember that the reflected line will be going in the opposite direction.

9 A few gentle z-shaped lines in cobalt blue help to suggest sky reflections as well as adding a surface to the water.

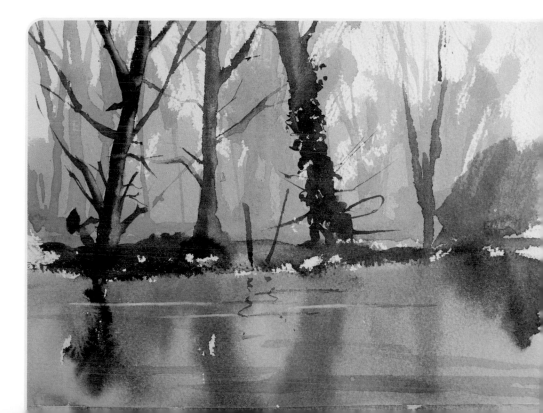

THE PAINTING

Grahame's top tip: spraying with water

You will be using the spray a lot in this painting. The spray allows you to easily make the paint run and blend. If you don't want the paint to run into an area you can simply mask the spray with your other hand. If the paint is too strong you can dilute it with the spray. If you make an appalling mess, just spray hard close to the paper and it all runs off. Put on your raincoat and boots and have some fun!

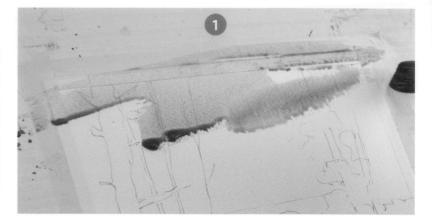

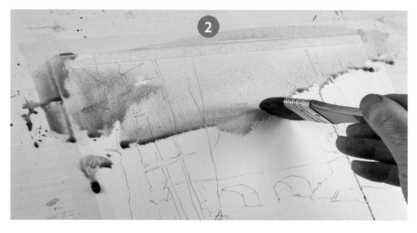

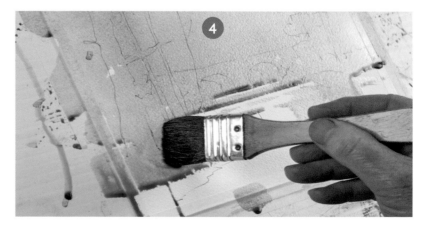

1 Transfer the outline from page 100 onto watercolour paper. Begin with a light spray all over. Start at the top and work steadily down using your wash brush. Start with cobalt blue for the small area of sky and change to quinacridone gold where the trees begin.

2 In this painting you are trying to achieve a varied blend of background colour. The actual colours used are not really that important simply because the painting is so wet that they will all blend and mix together. Use any colours you like, but you must keep everything wet.

3 Leave a few horizontal lines of paper untouched. This will ultimately be sparkles of light on the river at the end of the painting… hopefully.

4 You must keep the wash wet as you go down the paper. It is vital that you do not dwell on any part or the wash will begin to dry and you will lose the lovely softness.

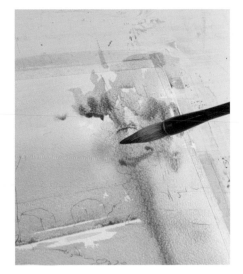

5 Notice how, although some very bright colours were used, they have all blended with each other resulting in a much more muted effect. When painting in this way don't worry if a colour looks too bright when applied. It will dull and lighten as it blends and dries.

6 Now for the fun part. You want to gradually build up stronger background colours but still let them blend. By applying the colour with your large round brush and immediately spraying it you will get lots of blending.

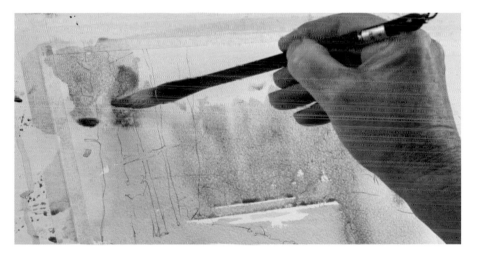

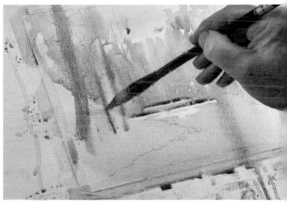

7 Keep largely to mixes of French ultramarine, burnt sienna and quinacridone gold. As long as the wash stays soft you cannot make a mistake, so do not try to control any runs.

8 Although you paint a few vaguely trunk-like shapes these will probably disappear in the dampness of the spray.

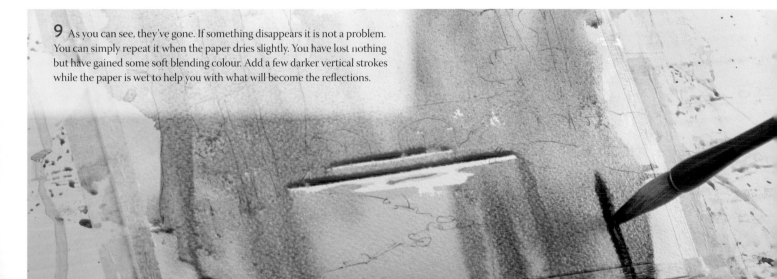

9 As you can see, they've gone. If something disappears it is not a problem. You can simply repeat it when the paper dries slightly. You have lost nothing but have gained some soft blending colour. Add a few darker vertical strokes while the paper is wet to help you with what will become the reflections.

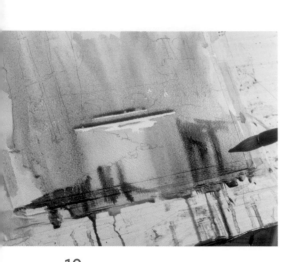

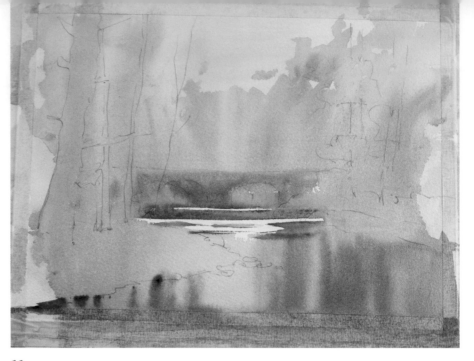

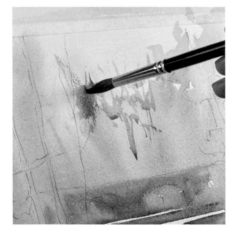

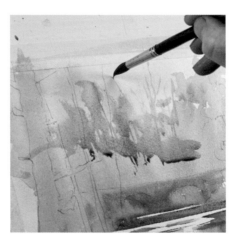

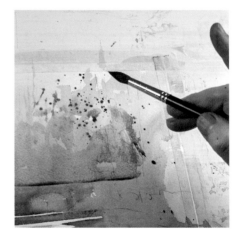

10 Add a few more vertical strokes. Remember to use stronger paint when working on a wet surface. The water on the surface will dilute the strength of the paint you apply.

11 Roughly paint in the bridge, more to remind yourself where it is. Allow everything to dry.

12 Paint the middle-distance trees with some cobalt blue and retain at least some of the definition. Only use the spray if you really make a mistake. As you will be creating more detail, change to your medium round brush.

13 Still try for simple shapes. Remember that you have more detailed trees yet to come.

14 Some splatter with the French ultramarine, burnt sienna and quinacridone gold mix hints at random leaves.

15 Link some of the splattered leaves to trunks and branches. Keep thinking about groups of trees, not individual trees.

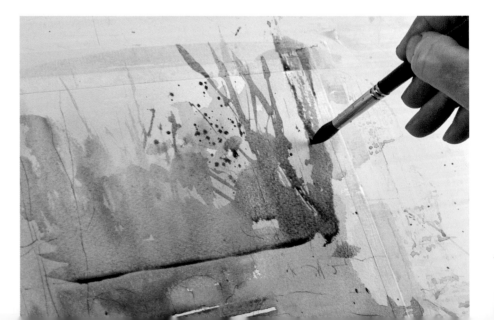

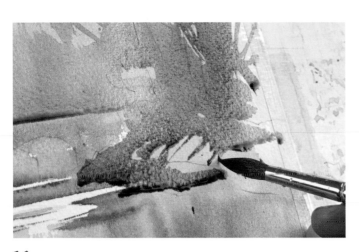

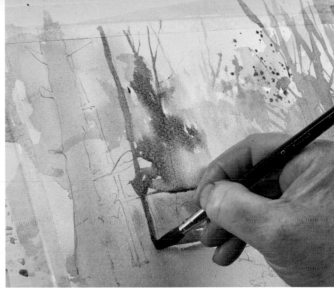

16 Link the trunks to the ground and continue down the riverbank. The bank slopes, so paint it with sloping strokes.

17 Do the same thing on the near side of the river. Spray the leaf clusters to the right of the trunk to improve their shape. They look much better.

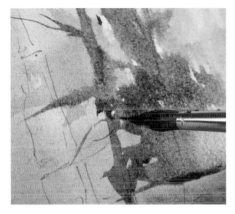

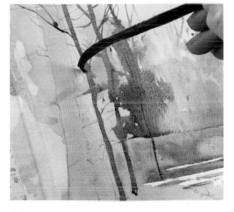

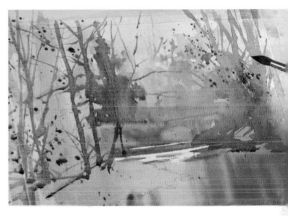

18 Drop a little pyrrole (Winsor) red into the wet area. This colour was not actually there, but doesn't it look good?

19 Vary your mix slightly and continue with the simplified trees, allowing each one to blend with the next. The smaller branches are best painted with the sword liner.

20 Using a little more splatter helps keep things varied.

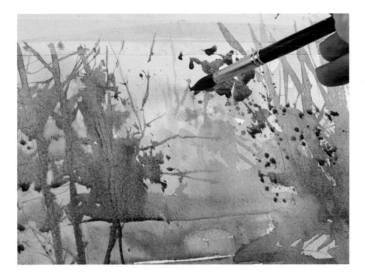

21 Splatter only works so far. For more substantial leaf areas, paint directly with the brush.

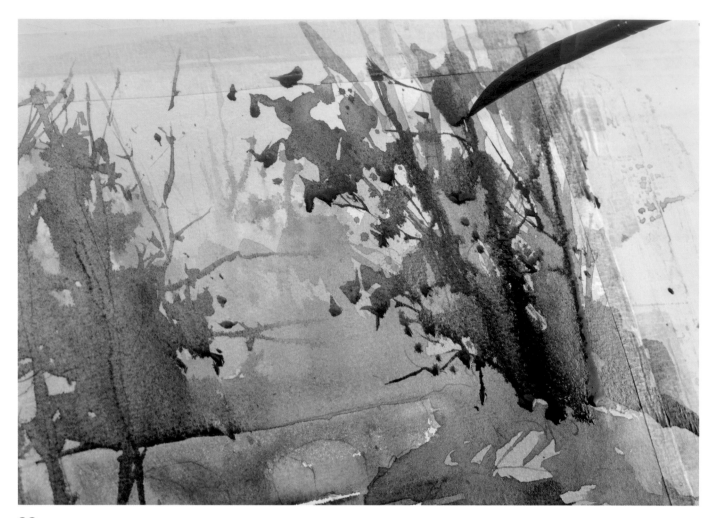

22 Use your sword liner with a dark mix of French ultramarine and burnt sienna and work it into both the wet and dry areas, giving you a blend of soft and hard edges.

23 Do the same thing at the other side. It is really a case of continuing to work into the different areas until you get what you consider to be sufficient definition.

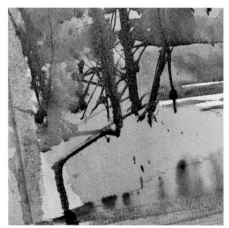

24 The bottoms of the trees are separate. This would work well for snow.

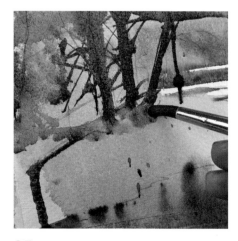

25 It might not work so well for other seasons. Simply blend the bottoms of the trees together, effectively linking them to the ground.

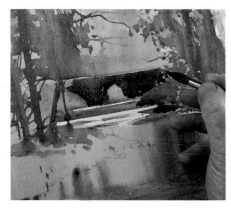

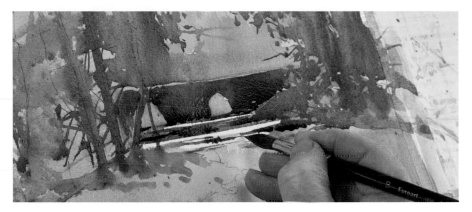

26 The bridge needs to be much darker. French ultramarine and pyrrole (Winsor) red produce a rich dull purple dark that suits the autumn feel.

27 Using the same mix, hint at a few dark reflections of the bridge.

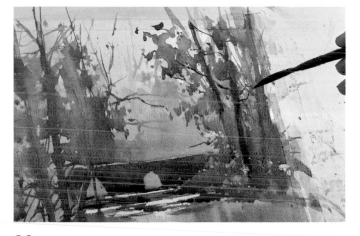

28 Still keeping the same mix, add a few dark touches to the trees. This is really for tonal variety rather than for an accurate reproduction of the actual subject.

29 It is important to continue the darks into the riverbank to emphasize the connections.

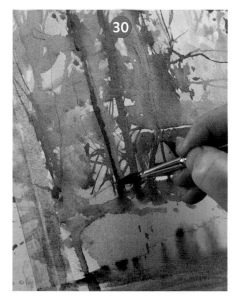

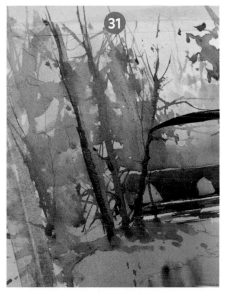

30 Repeat the darks on the near side using the small round brush.

31 Then use the sword liner for the narrower branches. If you are having trouble finding a sword liner, a rigger will do a similar job although it is not as versatile a brush. The important thing is that whatever you use must have a fine point. Bear in mind that the points of brushes do eventually wear out, so treat yourself to a new one once you lose the point.

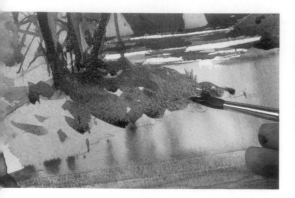

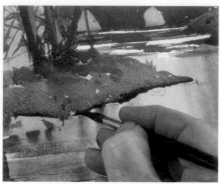

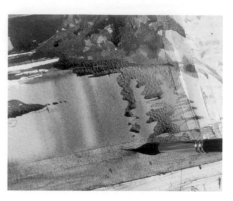

32 Using French ultramarine and quinacridone gold, add a little grass colour to the left bank while the wash here is still damp.

33 This allows the green to gently blend, creating intermediate colours to make the area more interesting.

34 Time now for some more definite reflections. Reflections tend to have duller colours than the objects being reflected. A little burnt sienna is useful to dull the green and try using little zigzag strokes to suggest ripples.

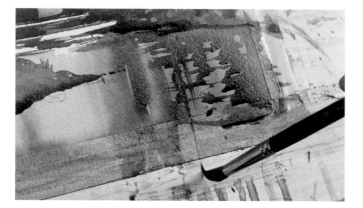

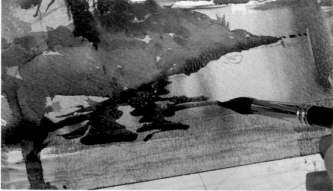

35 Extend the reflections across the river with a few vague zigzags and a couple of vertical strokes, all blending together.

36 Using French ultramarine and burnt sienna, do the same thing on the left side. The darker mix will catch the eye more in this nearer area. Allow everything to dry.

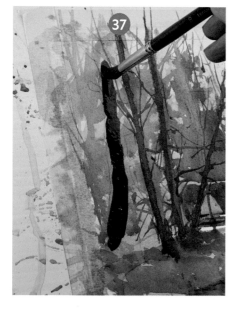

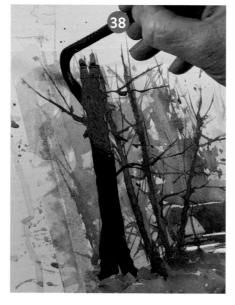

37 Time to be bold. With the same French ultramarine and burnt sienna mix paint the main trunk of the tree with your medium round brush.

38 Then use the sword liner to paint the side branches. Make sure you hold the sword liner about halfway down to allow plenty of freedom of movement.

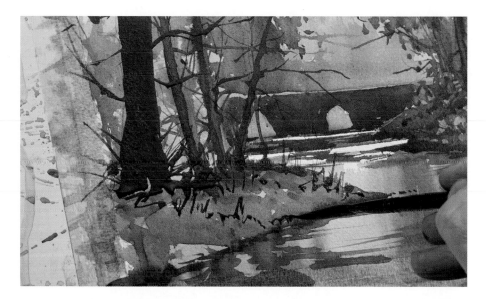

39 Again, continue these darks down on to the bank, hinting at little tufts of grass.

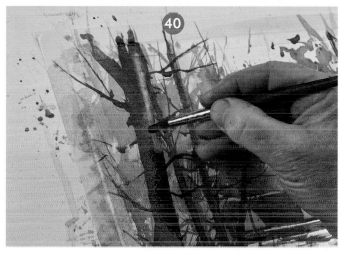

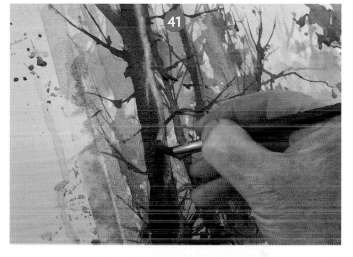

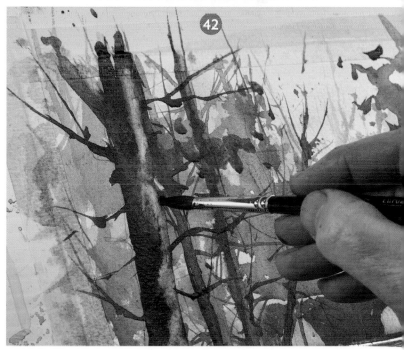

40 While the tree is still quite damp (notice the shine on the paint), lift out some light on the right side with a gentle scrubbing motion. If it dries before you have a chance to do this, don't worry, you will just need to scrub a little harder.

41 The brush will rapidly fill with the paint being removed so it is necessary to rinse and shake or squeeze the brush frequently to keep it clean.

42 Using a burnt sienna wash, indicate some clumps of autumn leaves on this foreground tree.

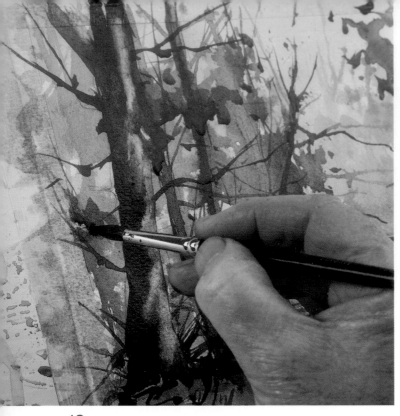

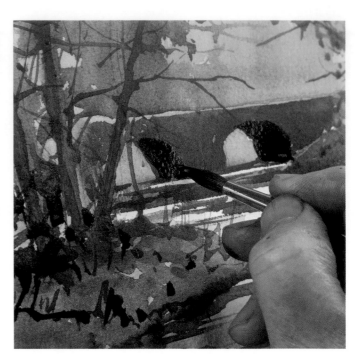

43 While the leaves are still wet, drop in some strong French ultramarine and burnt sienna. The foreground trees should have more tonal variety than the middle-ground trees.

44 The same dark is used for the underside of the bridge arches.

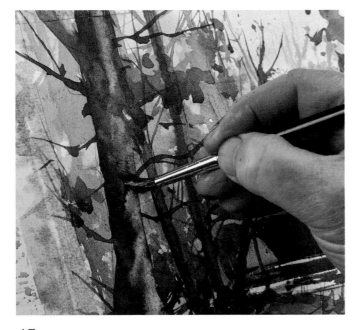

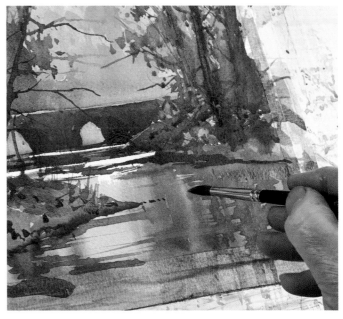

45 After the tree has dried, apply a weak wash of quinacridone gold on to the light side of the tree. This is a good way of suggesting the warm autumn light.

46 Finally, paint a little meandering cobalt blue wash zigzagging down the paper. This helps to counter the predominant vertical reflections and hints at the surface of the water.

The finished painting, shown opposite, is reproduced at a larger size on pages 96–97.

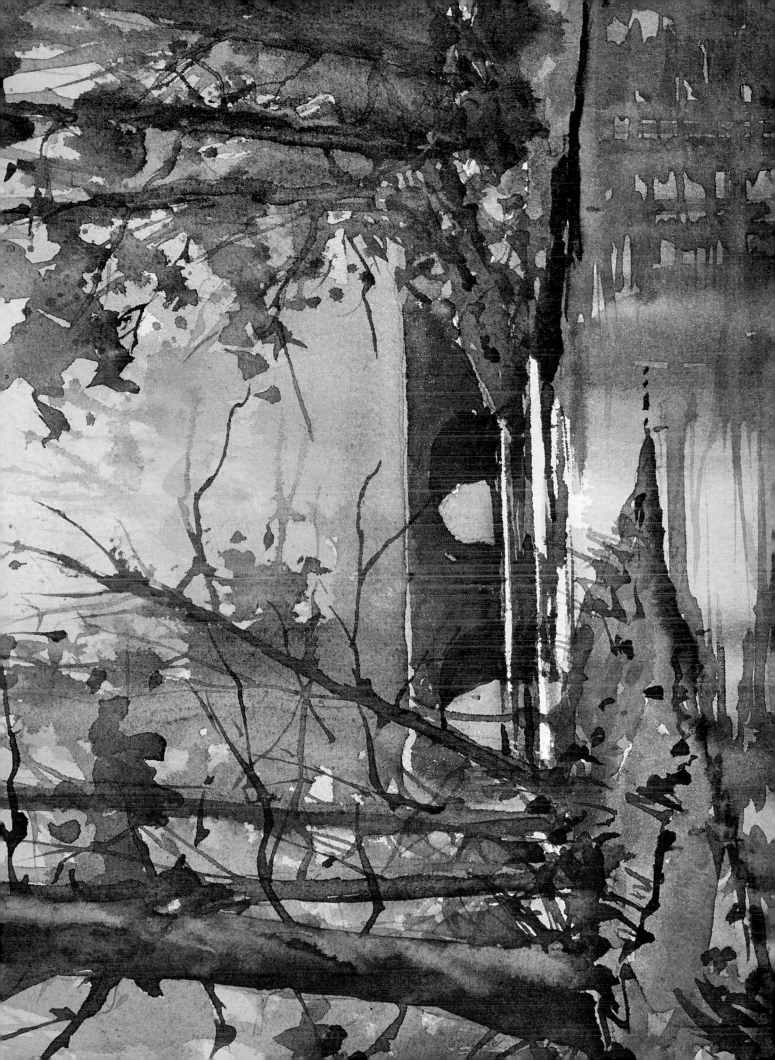

4. ALPINE RIVER

The subject of this painting is a river with little waterfalls, along with a snow-covered mountain in the distance. Following on from the broadleaved trees we have been painting, you will also get a chance to paint conifers to give us that authentic alpine look.

BEFORE YOU START

YOU WILL NEED
Wash brush, large, medium and small round brushes, sword liner, spray bottle, outline 4 (see page 101)

COLOURS NEEDED
French ultramarine, phthalo blue (green shade), cobalt blue, quinacridone gold, burnt sienna, pyrrole (Winsor) red, quinacridone magenta, white gouache

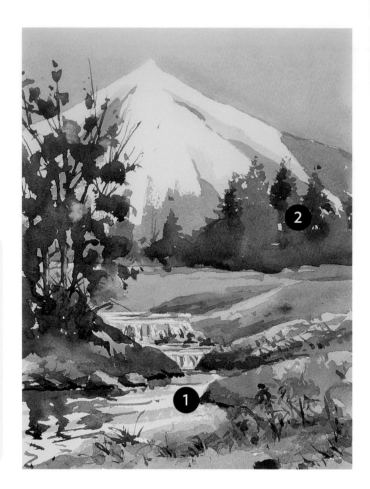

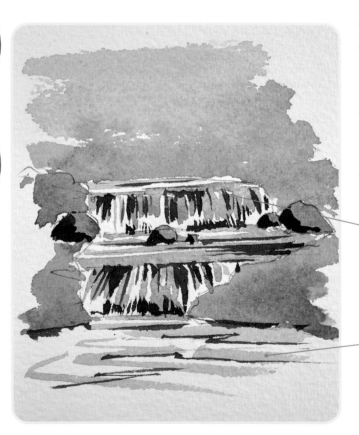

Technique 1: Directional strokes

You should paint the different parts of your painting with directional brushstrokes that describe the object you are painting – vertical strokes for a wall; horizontal strokes for a river; angled strokes to suggest a slope. Although many strokes will simply blend with the next, you will always have some that show the direction they were painted in. It is equally important not to paint with strokes going in an inappropriate direction. For example if you use angled strokes for a river, it will look as though the river is slanted – something that is just not possible.

Painting downward strokes curving slightly to the right and left of our viewpoint clearly indicates the direction of the water flowing down the waterfall.

The flat parts of the river should be painted with horizontal strokes. As these approach the extreme foreground, a lazy s- or z-shape of stroke will suggest the flow of the water.

Technique 2: Connecting washes

Connections are so important in a painting, especially when we have a group of what are essentially the same objects. In this example we are trying to convey the effect of a group of trees, rather than a specific number of individual trees.

We have four trees here, each one hard edged against the next. There is no sense of the trees being a connected group. When you see a group of objects, ask yourself how many there are. If you struggle to count them you should paint the group rather than the individuals.

Here the trees have been painted as a single connecting wash. There are still four trees – or are there? The connecting wash may indicate four trees but is there not also the suggestion that there could be some smaller trees or shrubs at the bottom? This slight degree of uncertainty adds to the interest of the painted area. It gives the viewer something to think about.

THE PAINTING

Grahame's top tip

The portrait shape helps to accentuate the height of the mountain. Strong vertical objects are often better suited painted in this aspect.

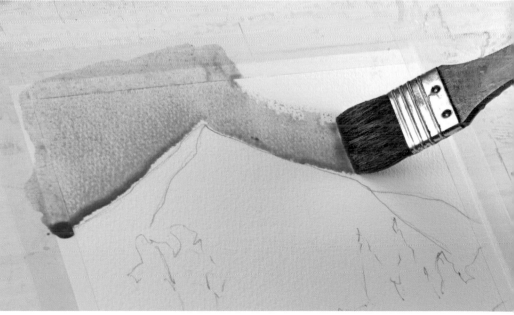

1 Trace and transfer the outline on page 101 onto your watercolour paper. With a good wet wash of cobalt blue, paint the sky but not the mountain. A snow-covered mountain is one of the rare situations where the sky must be darker than the mountain.

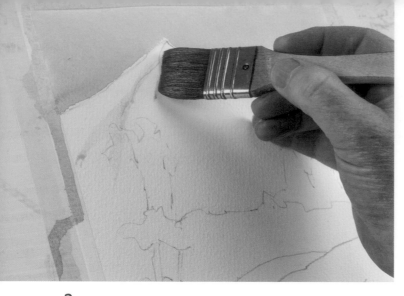

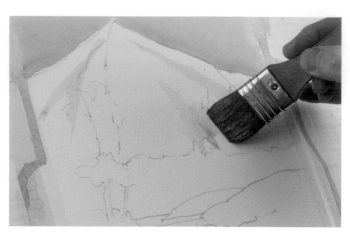

2 With the same cobalt blue wash, simply indicate shadows on the mountain. Notice how the direction of the strokes helps to suggest the conical shape.

3 Try to vary the stroke shapes on the mountain. If you simply repeat the same strokes on each side it won't look natural.

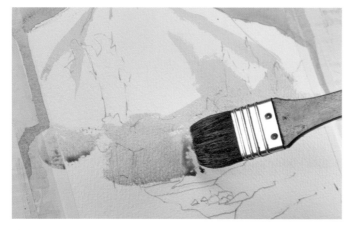

4 Adding a little quinacridone gold to the cobalt blue, paint the vegetation to the bottom of the painting.

5 Leave the river uncovered. It is important to have some bright highlights on the river later.

6 As you approach the bottom of the paper, introduce some pyrrole (Winsor) red into the mix. As well as warming the near foreground this indicates the colour of a few wild flowers. It is too early to think about detail.

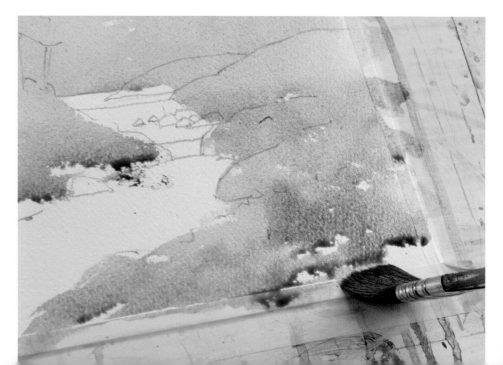

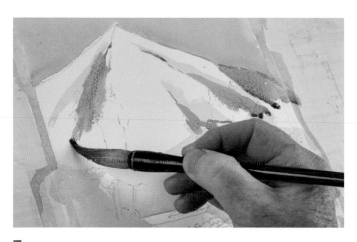

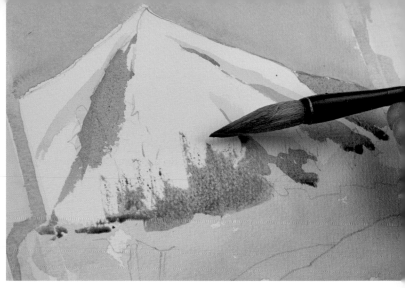

7 Change to your large round brush and use a mix of French ultramarine with a touch of burnt sienna to grey it slightly, increasing the strength of parts of the shadows.

8 Use the same mix with an upward motion of the side of the brush to hint at the rough edges of the distant conifers. Some of this wash will blend with the mountain shadows to increase the illusion of distance.

9 Some of the same mix hints at shadows on the grass and with the addition of a little quinacridone gold you can paint some more obvious grassy shapes in the foreground. Allow everything to dry.

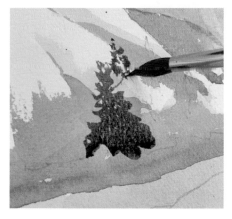

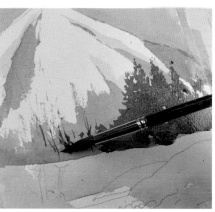

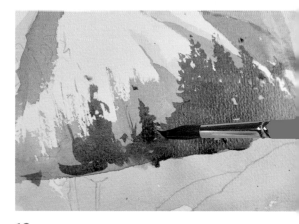

10 Conifers are often a quite cold green. Use the mix of French ultramarine and quinacridone gold with the emphasis on the blue and use the tip of your medium round brush and a side-to-side motion to describe the shape of the tree.

11 Do not pause to admire your fine conifer, but continue to paint the group of trees so that they blend. A few little vertical lines help to ensure that the trees are reasonably symmetrical about the centre as is the case with this type of pine tree.

12 When painting the group of trees it is still important to include enough indication of the shape of the trees so that the viewer can identify them, but it is vital that they all connect.

13 While the trees are still wet, introduce a strong mix of French ultramarine and burnt sienna to suggest the darkest parts of the trees. Note that this mix is actually a dark grey, but it will read as a dark green.

14 The important factor is that it is dark. The darkest version of any colour is what we would see as black. The tone or value is much more important than the actual hue.

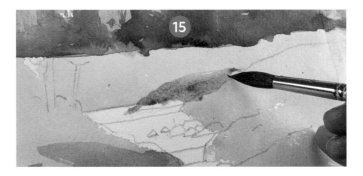

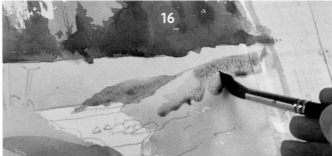

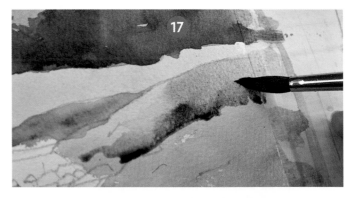

15 In order to suggest the hilly shape of the grass, paint parts of it to show the tonal variety that would be expected. For these greens, again use your mix of French ultramarine and quinacridone gold but vary the proportions.

16 The alternating dark and light tones break up the flat first wash, giving variety and interest.

17 Introduce a little quinacridone magenta as you near the bottom of the paper.

18 Continuing to the bottom, vary the colour even more. You will never have a problem with colour not being 'correct' as long as the tone is right.

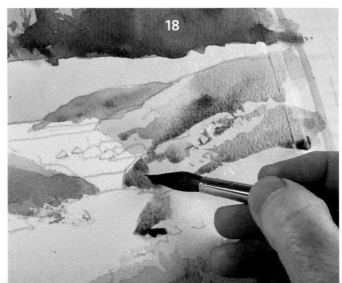

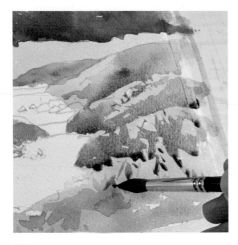

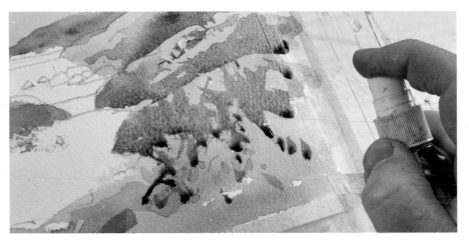

19 At the bottom of the paper, which is of course the closest area, use some more obvious flicks of the brush to hint at grass and flowers.

20 If you decide you are not entirely happy with them, your spray bottle will allow the marks to soften and blend, making them less obvious. Remember that the spray will create more drips which must be lifted with a damp brush before continuing.

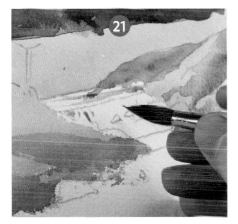

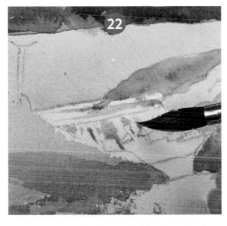

21 Using a mix of cobalt blue in water, paint the river with horizontal strokes for the pools and vertical strokes for the falls.

22 Make sure to leave plenty of untouched paper for highlights. It is more difficult to remove paint than to add it, so take care not to add too much blue.

23 With this stage of the river completed, add a weak wash of French ultramarine and burnt sienna to the rocks. You are aiming for a warm brown/grey, so your mix will have more burnt sienna than French ultramarine.

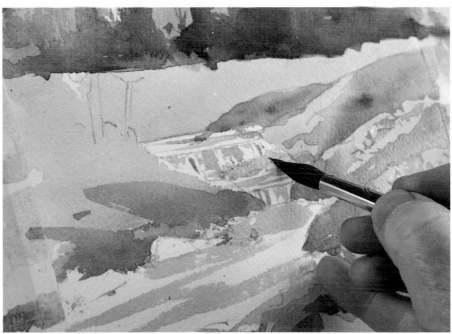

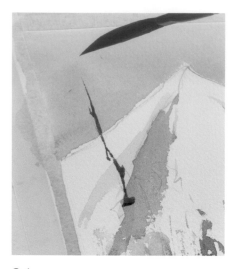

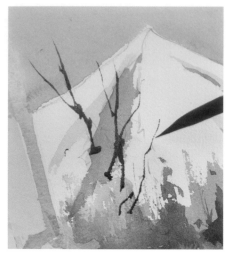

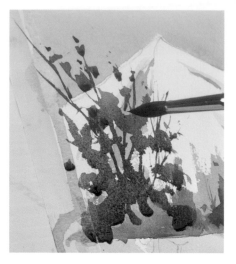

24 Using the sword liner, start to paint the sapling on the left with a few strokes of a grey mix of French ultramarine and burnt sienna.

25 Use quick, jerky strokes to simulate the angularity of the twigs. Very few trees have curvy twigs – most have reasonably straight twigs that divide with quite a sharp angle.

26 While the twigs are still damp, add your clumps of green leaves using French ultramarine and quinacridone gold, keeping the edges complex and varied. The clumps should blend with the twigs but not overpower them.

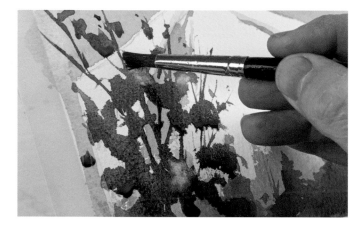

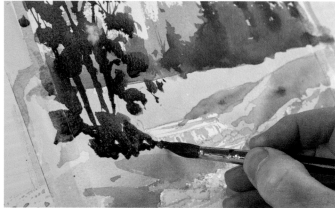

27 Create variety by lifting some of the green to give highlights. The paint will rarely lift completely, giving you a suitable pale green rather than unsuitable white paper.

28 Also add a darker mix of French ultramarine and burnt sienna so that you have a good variety of tones.

29 Continuing down into the rocks helps to connect the trees, undergrowth and rocks, but leave some hard edges here to show one rock in front of another.

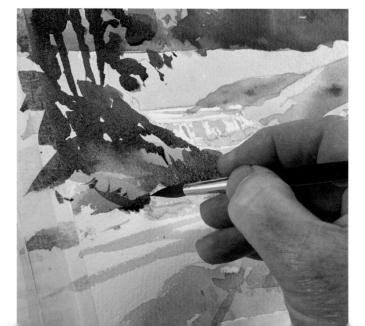

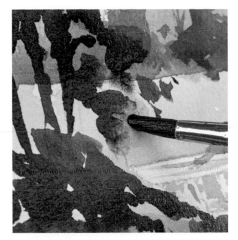

30 Looking again at the trees, you might feel that there are too many hard edges, so you can soften a few of them, making them less obvious.

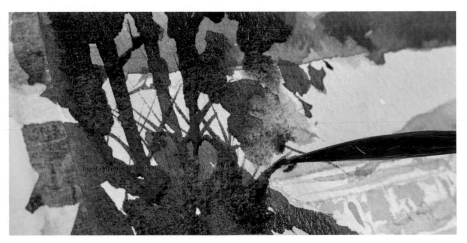

31 Undergrowth is generally characterized by lots of little shoots going in all directions. Your sword liner allows you to paint the necessary fine lines.

32 Lifting a little light off the right side of some of the tree trunks helps to show their roundness.

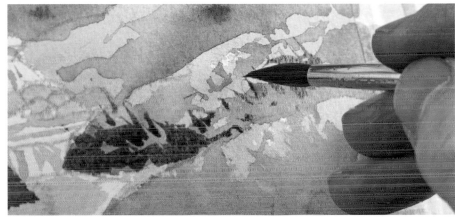

33 Now go back to the foreground grass with French ultramarine and quinacridone gold. There is always a tension between suggesting enough of the grass to make it read as grass but not so much that the grass takes over. The best thing to do is to stop before you think you have done enough.

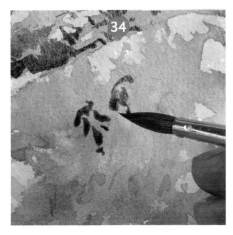

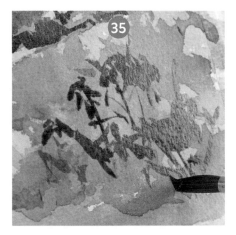

34 With some pyrrole (Winsor) red and water, paint a few petal shapes. Try not to paint a flower that could be identified by a botanist. Instead, simply try to suggest the general shape of a typical flower by using some nicely shaped brushstrokes.

35 Allow some green stalks to blend with your petals. Painting separated flowers will look very artificial, so make sure you paint a group of flowers that all blend together. Again, stop at the point where you feel you need a few extra marks. Better to add them later than have to remove too many.

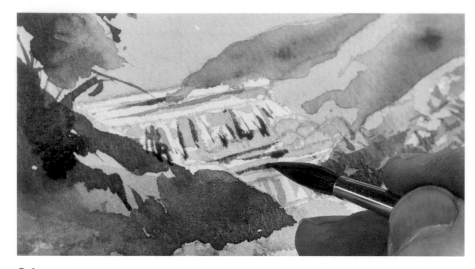

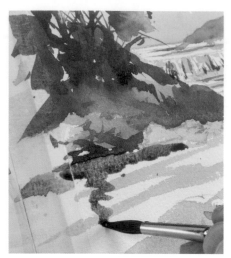

36 Go back to the water to add a few final brushstrokes with a dark mix of French ultramarine and burnt sienna. You now have three tones here – light, medium and dark – which makes things interesting.

37 A wavy line of French ultramarine and quinacridone gold works quite well to hint at reflections. You don't want so many reflections in your painting that they become too interesting. The reflections are a side interest, not the main focus.

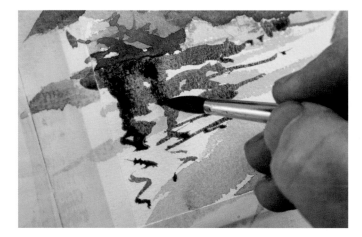

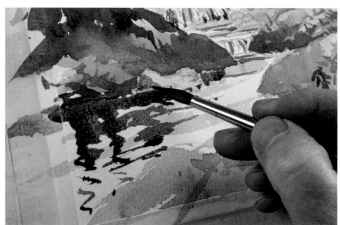

38 Adding some dark (French ultramarine and burnt sienna) into the wet reflections provides variety.

39 Add some of the same mix but slightly weaker to the shadow side of the rocks.

40 Follow this up with very strong French ultramarine and burnt sienna just at the waterline.

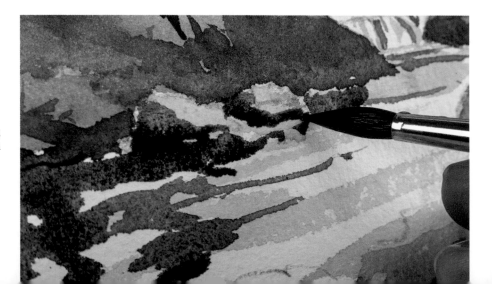

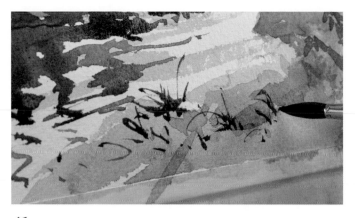

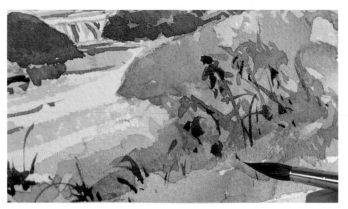

41 You can now add a few more tufts of grass with your mix of French ultramarine and quinacridone gold. It is important that the painting balances and painting a little of everything, then a little bit more, makes it easier to judge when the painting is finished. Finishing part of a painting when other parts are not even started makes judging the effect very difficult.

42 A few stronger petals of pyrrole (Winsor) red complete the wild flowers. By painting the petals in two stages you get a slight difference between them – again, this provides interest.

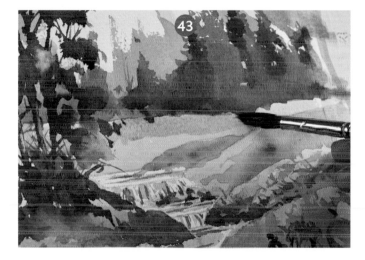

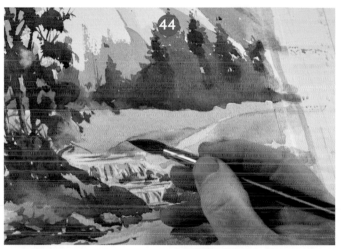

43 The distant grass appears to be too close, so a glaze of weak cobalt blue helps to push it back.

44 Be careful to paint the wash up to, but not over, the closer areas of grass.

45 When this is dry, add a few cool shadows to the distant field using French ultramarine and burnt sienna.

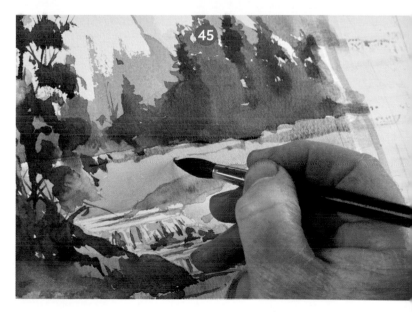

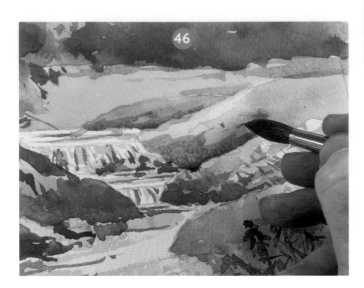

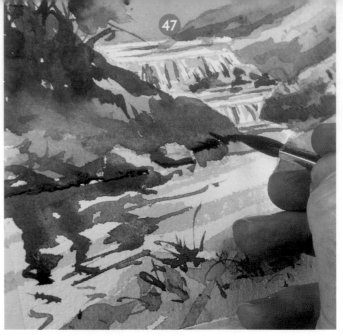

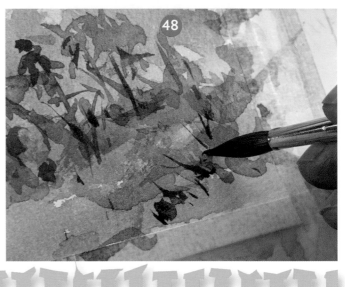

46 Use a warmer shadow mix of French ultramarine and pyrrole (Winsor) red for the closer areas (remember aerial perspective!).

47 Mix up your very strong sticky dark using French ultramarine and burnt sienna with virtually no water and use this to increase the contrast between the rocks and the water.

48 For a final touch, if you can't resist, add a few grass tufts.

Grahame's top tip: removing pencil marks from traced outlines

In general a few visible pencil marks do not cause any issues with the finished painting, but there is an exception with the top of hills or mountains. In these cases the hard pencil line accentuates the top of the mountain, tending to make it 'come forward'. The solution is simple – just erase the pencil line. If the line has initially been lightly applied, a decent art eraser will remove it, even if it has been painted over.

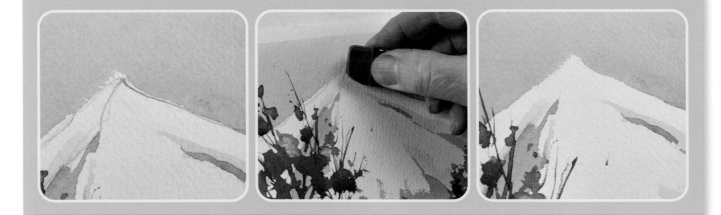

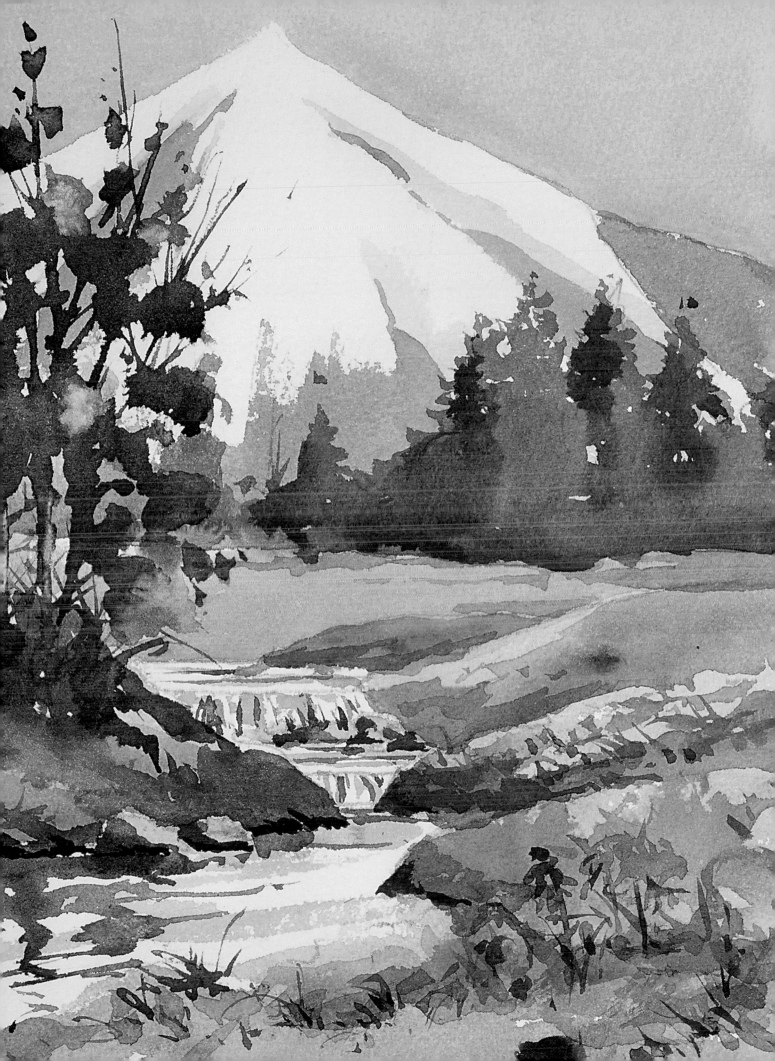

5. SPRINGTIME IN THE PARK

This subject is set at the beginning of spring before the leaves come but with some bright colour from early flowers such as daffodils. I have included a fairly close building in this one, as well as receding trees and drifts of daffodils.

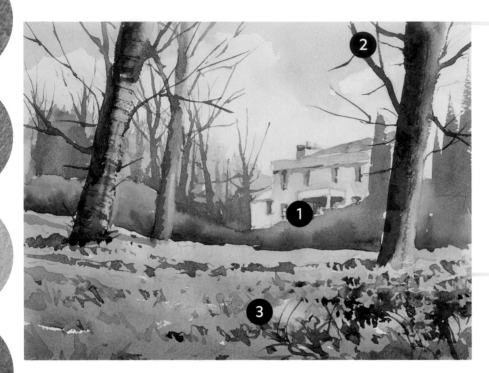

BEFORE YOU START

YOU WILL NEED
Wash brush, medium and small round brushes, sword liner, sponge, outline 5 (see page 102)

COLOURS NEEDED
Cobalt blue, French ultramarine, pyrrole (Winsor) red, quinacridone magenta, cadmium yellow, quinacridone gold

Technique 1: Integrating buildings into a landscape

There is a difference between a painting of a building that happens to be in the countryside and a painting of a landscape that happens to have a building in it. In a landscape it is important that the building integrates with its surroundings rather than dominates.

Here the cottage is isolated from the landscape. The colours are too bright, tonal contrast too strong and there are no connections or overlaps with the elements in the landscape.

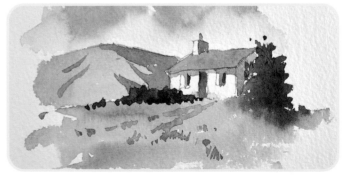

In this image you can see how the muted colours and partly soft edges help to avoid this isolation. This is also helped by a better balance – there is less detail and contrast in the building but more in the grass and mountain.

Technique 2: Creating winter trees

This is a method to suggest simple winter trees. Rather than attempting to paint every twig, I merely suggest the twigs with drybrush.

1 Begin by brushing a greyish mix of French ultramarine and burnt sienna using the side of your brush. The amount of paint in the brush will determine how well this will work. Too much and you may not get the drybrush effect.

2 It is important to paint the brushstrokes in the direction the tree grows out from the trunk. This and the drybrush effect itself is enough to suggest twigs.

3 Using the same mix with your sword liner, paint in some of the major branches and trunk.

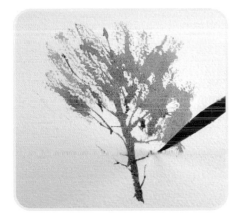

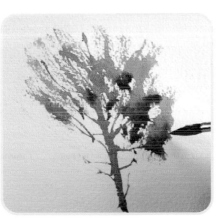

4 On a wild tree the side branches and twigs generally continue down the trunk which is much more interesting to paint. Park trees usually have these cut off to above head height.

5 Going back to your round brush, drop some of the same mix but stronger into the still-damp twig wash. This helps to suggest the light and shade.

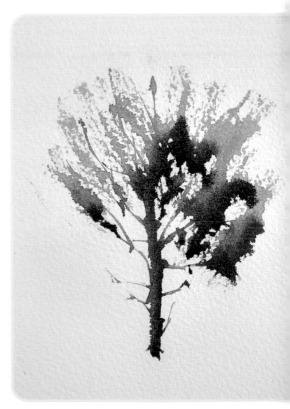

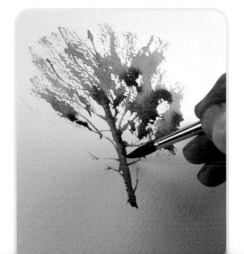

6 Continue the darker mix down the side of the trunk. This should drift slightly into the left side creating a sense of roundness.

Technique 3: Creating drifts of flowers

Drifts of flowers in a landscape must be simplified. It would be extremely tedious to paint every flower and you would be disappointed to find that the effect would be rather unnatural. In reality we can focus our eyes on only a few flowers. The rest become no more than soft colour without definition. This is how to paint a drift of bluebells.

1 Begin by painting a green mix of French ultramarine and quinacridone gold. This is our distance.

2 While the green is still wet, introduce a purple/blue mix of French ultramarine and quinacridone magenta.

3 Continue with alternate green and purple until about halfway down.

4 At this point, mix a stronger green and purple and continue down the sheet.

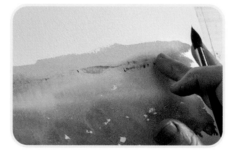

5 After the wash has completely dried, hint at some distant flowers with no more than varied dots and dashes of purple. Think morse code. Use the tip of your finger to slightly smudge the marks.

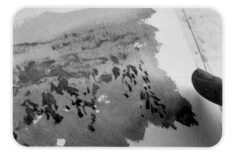

6 Continue down with the purple, making the marks bigger and less smudged. Save any hint of actual bluebell flower shapes for the extreme foreground.

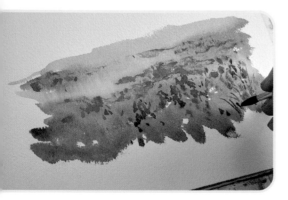

7 Add a few green leaves and stems. Don't be too careful. Rather surprisingly it looks more realistic if the stems don't precisely meet the flowers.

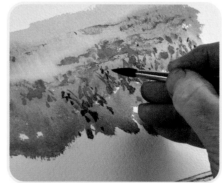

8 Finish with only a few extra darker purple flowers. Again, keep these for the foreground. The final effect should suggest flowers disappearing into the distance becoming smaller and less defined as they go.

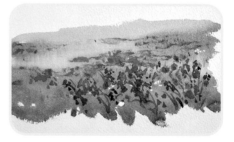

THE PAINTING

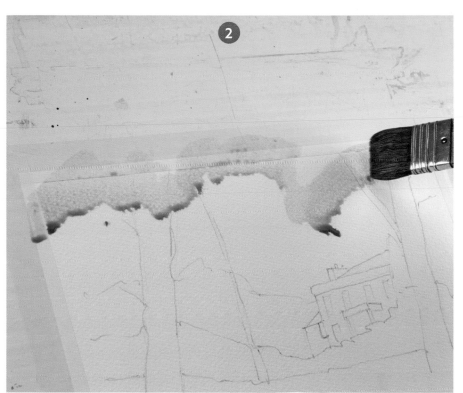

1 Transfer the outline from page 102. It doesn't include many side branches on the trees. These are better painted with quick, confident strokes rather than following a pencil line with slow, careful strokes.

2 There is a fair amount of sky in this one, so introduce a few clouds. Paint a cobalt blue wash down to the top of the clouds.

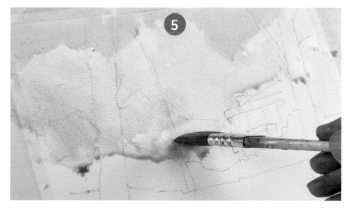

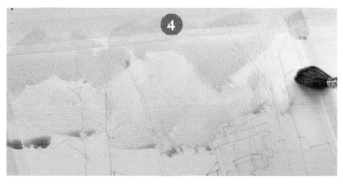

3 While the blue wash is still wet, use a small natural sponge, wetted and squeezed dry, to blot the edge of the clouds to soften the line. Rinse and squeeze the sponge often, or you will simply redistribute the blue.

4 Work a weak burnt sienna wash into the sponged area to create your clouds. Clouds look better when they have a warm tinge. Using burnt sienna avoids any chance of the clouds turning green as they could if you used a yellow such as raw sienna.

5 Reintroduce the cobalt blue wash at the bottom of the clouds. Here it should be weaker than at the top of the paper. Paint down to where the grass begins. Ignore the line of shrubs for the moment and do not leave a space for them.

6 With a mix of French ultramarine and quinacridone gold, apply a green wash to hint at the grass.

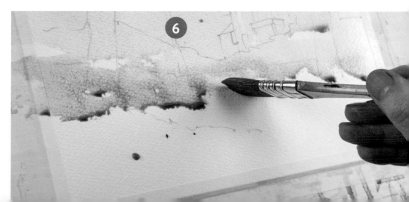

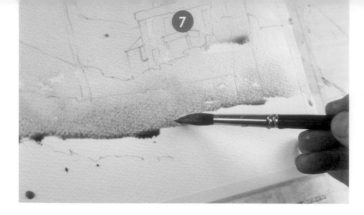

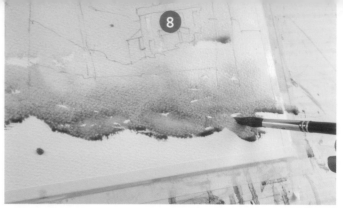

7 While the green is still wet, add some pure cadmium yellow wash for the daffodils.

8 Continue down with alternating green and yellow areas.

9 Then finish with the green down to the bottom of the paper. At this point allow the paper to dry completely.

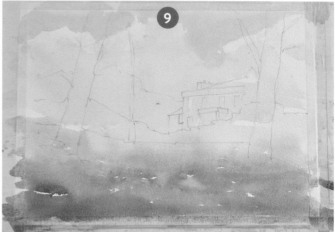

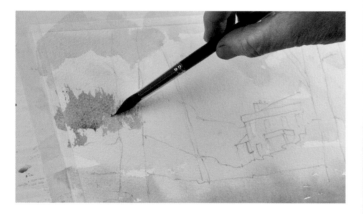

10 Using the side of your medium round brush, aim for a rough edged wash of distant trees, using French ultramarine and pyrrole (Winsor) red. Paint down to the top edge of the shrubs and building.

Grahame's top tip: waiting for the paint to dry

The decision as to when to let paint dry is fairly straightforward. If you want a hard-edged mark, paint on to dry paper and if you want a soft-edged mark, paint on to damp or wet paper. The worst time to paint is when the previous wash is just on the point of drying as all sorts of unexpected and undesirable things can happen. If you think the paper has dried, touch it with the inside of your wrist. If it feels cold, give it another couple of minutes.

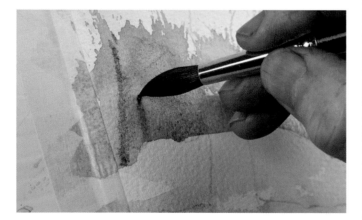

11 While still wet, start to paint a few trunk shapes. If the trunk marks merge completely, just wait another twenty seconds and try again.

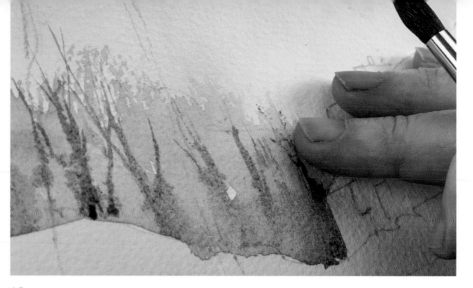

12 Continue across the paper, varying the thickness of the marks you make. Just ensure that the marks get thinner as they grow further from the trunk.

13 It is important to allow the marks to merge as you paint across the paper – remember to give the impression of a group of trees, rather than individual trees.

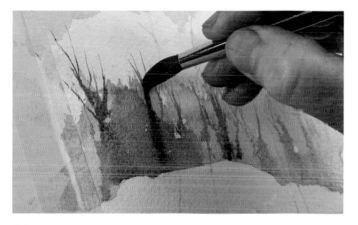

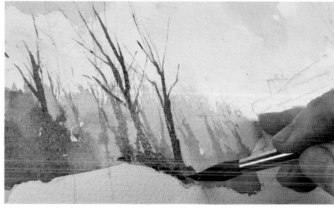

14 Now that the paper has dried a little, repeat the process from step 11.

15 Using a slightly stronger mix gives the effect of trees in front of trees, but in a subtle way where there are soft blends. Allow to dry.

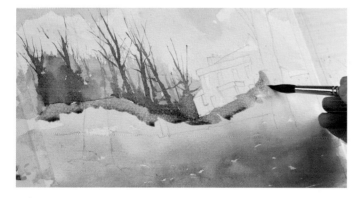

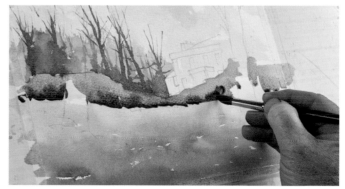

16 Paint a line of green for the shrubs using your French ultramarine and quinacridone gold mix. Leave a little space for the main foreground tree. It is not essential to do this, but it could help you with light on the trunk later.

17 Paint into the bottom of the first line with a second line of stronger green and paint the shrubs down to where the grass begins.

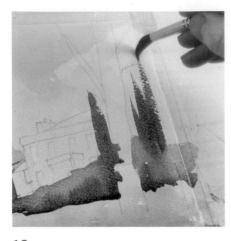

18 Add a few cypress trees with a single upward vertical flick of the brush. Practise this first. It is not difficult, but there is a knack to it and it is important that you feel confident making the stroke. Your first few attempts will probably bend over at the top. Lift your entire arm for the stroke, rather than just your wrist.

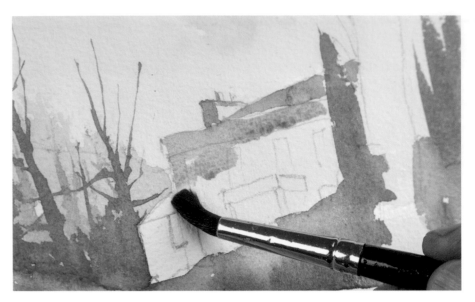

19 At present the building cannot be distinguished from the sky. Use a slightly greyer version of the tree mix (add a little burnt sienna to it) and paint this on the building where it meets the sky. Then soften this so that it gently disappears into the rest of the building area.

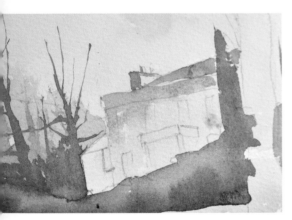

20 This gives a tonal contrast of the building against the sky, without really darkening the building as a whole. Allow to dry.

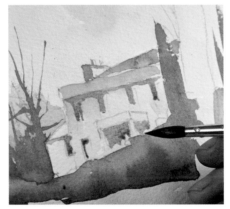

21 Using the same mix, paint shadows and windows as one single wash where possible. The top four windows, for example, are joined together with a line of shadow. This gives you one shape rather than five.

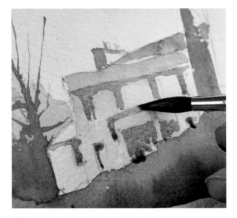

22 To separate the porch from the rest of the front wall, do the same as in step 19 and paint around the edge.

23 Quickly blend the stroke into the front wall but retain the hard edge that describes the porch. Allow everything to dry.

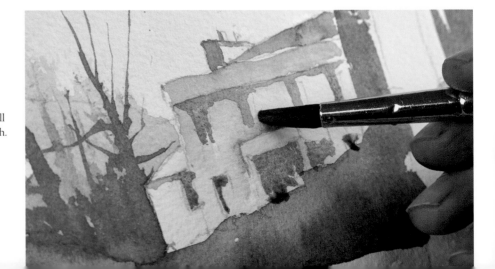

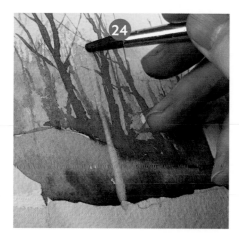

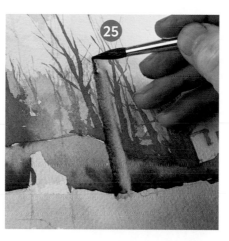

24 Using a damp brush, lift out one of the trees from the background colour. Don't worry if not all of the paint lifts. Lifting enough to show the tree as a light shape against a dark background will be sufficient.

25 While the lifted-out area is still damp, drop in a fairly strong dark mix of French ultramarine and burnt sienna. This should drift across the trunk giving a good impression of the cylinder shape.

Grahame's top tip: the order of painting trees

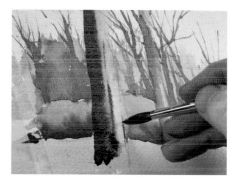

With any overlapping shapes I would always suggest painting the back shapes before the front shapes. I rarely leave space in the back shapes for the front shapes as this inhibits the application of a smooth, fresh background wash. The front shapes are usually darker and so can easily be painted over the back shapes and, if not, light can be lifted out. We can't paint light over dark, but we can paint dark over light.

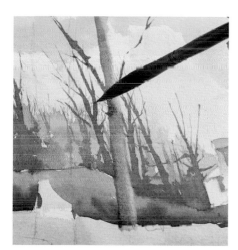

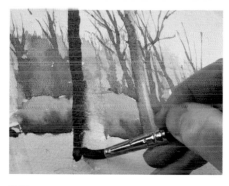

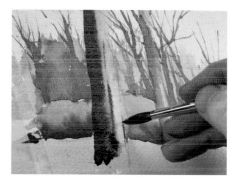

26 Add a few side branches using your sword liner, but notice how the dark edge has drifted right across and lightened considerably. Although you have the option to simply repeat the dark edge, you could decide just to make sure the next closer tree is darker.

27 Use the same routine of lifting out the space for the tree but this time wait a little longer before adding the dark edge. This should stop the dark drifting so far.

28 This time it has worked better, so take the opportunity to add a few darker vertical strokes to suggest the uneven surface. Tree trunks are cylinders, but rarely perfect cylinders.

29 Continue with a few more side branches, painting the trees beyond the edge of the paper and on to the tape. When the tape is removed, the trees will appear to grow beyond the edge of the painting rather than stopping suddenly.

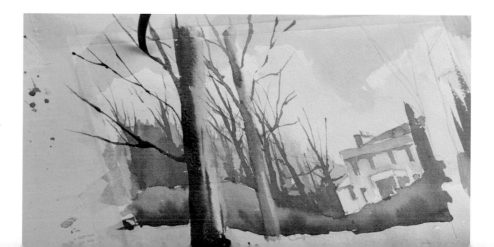

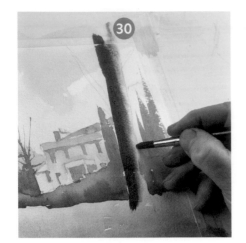

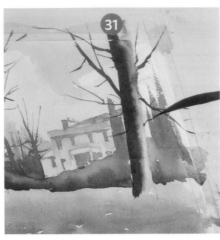

30 After painting the left edge of the closest tree, use a damp brush to encourage the dark edge to drift across. You will probably find that one of the methods of painting trees works best for you and it makes sense to use that method when possible.

31 Complete the structure of this tree with some side branches using the sword liner.

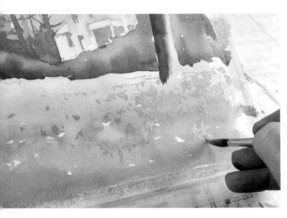

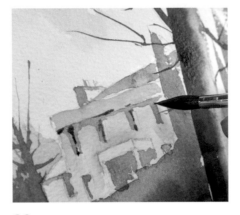

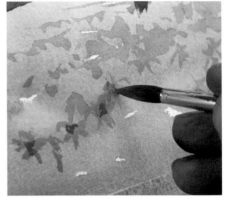

32 Continue the daffodils with a few dots and dashes of a strong cadmium yellow mix.

33 While the daffodils are drying, add a few touches of a dark French ultramarine and burnt sienna mix to the darkest shadows and windows of the house. This gives it more emphasis.

34 Mixing a strong orange from pyrrole (Winsor) red and cadmium yellow, hint at the coronas of some of the daffodils. Many daffodils have coronas that are the same colour as the petals. These are really difficult to paint and must be quite rare as they never appear in my daffodil paintings!

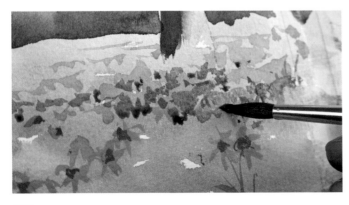

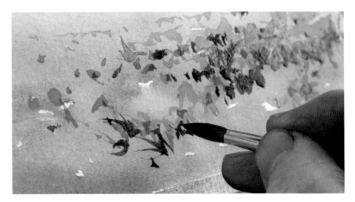

35 With a bright green mix of French ultramarine and quinacridone gold, isolate some areas of yellow as well as a few single blooms but try not to make the isolation complete. You will find that if you pick any area of yellow it will link to at least one other area of yellow. The idea is to create the illusion of identifiable flowers, not to actually paint individual specimens.

36 Follow this up with a few flicks of leaves using a slightly darker green.

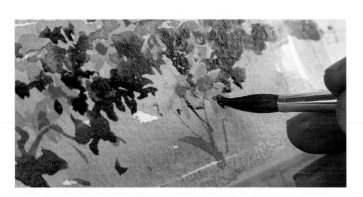

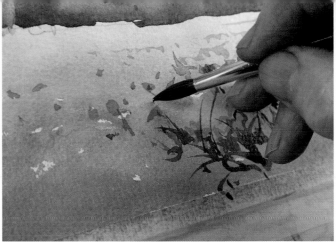

37 Now make a fairly strong French ultramarine and burnt sienna mix and drop this into parts of the wet green areas to create variety of tone.

38 There is no advantage in making all of the flower areas equally important. This looks uninteresting and allows the eye to wander too much. Reduce the strength and amount of the green as you move to the left of what will be your main clump.

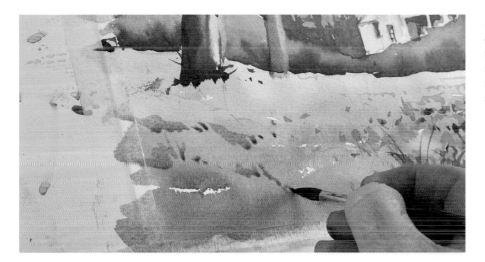

39 Finish with a few marks to hint at grass or leaves. Again, do not overdo this. It is very tempting to keep adding these little marks, but it is always better to add fewer than you think you need. You can always add more later, but you should find that you rarely need to.

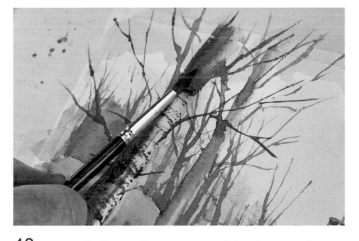

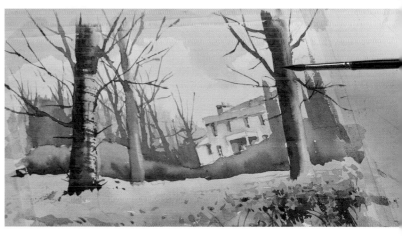

40 To create the illusion of bark, make some drybrush marks with a strong French ultramarine and burnt sienna mix. This should be so strong that it feels sticky under the brush. Use a sideways motion with the side of your small round brush, starting at the dark side of the tree. You can see the effect. If you get large, dark marks your mix is too wet or your brush too full and if almost no marks appear your mix or your brush is too dry.

41 Trees vary in their type of bark. The horizontal marks are great for trees like silver birches, but vertical marks are better for trees such as oak. Trees with a very smooth bark may not need any of these drybrush marks.

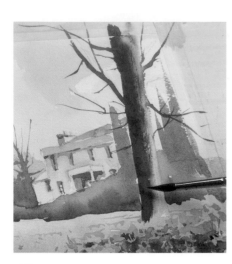

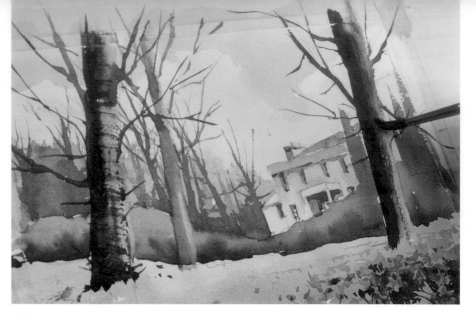

42 Try to make sure that the marks originate from the dark side of the tree. This helps to link them together rather than being randomly placed over the trunk.

43 A pale wash of a warm yellow such as quinacridone magenta with quinacridone gold works quite well on the sunlit side of the tree. Be careful not to make it too strong. You want to suggest warm bark, not bright yellow bark, but also remember that it will dry lighter.

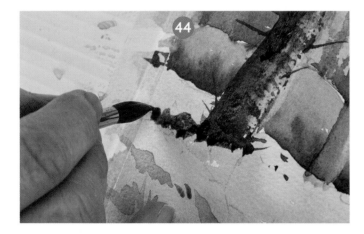

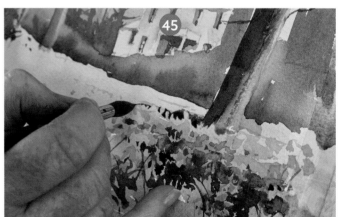

44 French ultramarine and pyrrole (Winsor) red give a great shadow mix. Begin the shadow on the dark side of the tree.

45 An uneven application will suggest the rough grass. A single unbroken shadow would suggest a bowling green smooth lawn which would be at odds with the semi woodland location.

46 Finish with a little shadow up the side of the tree itself. This may not be strictly necessary, but have some fun with these shadow marks. Always have a ready excuse for the times you might overdo things!

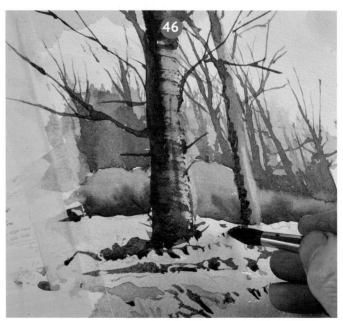

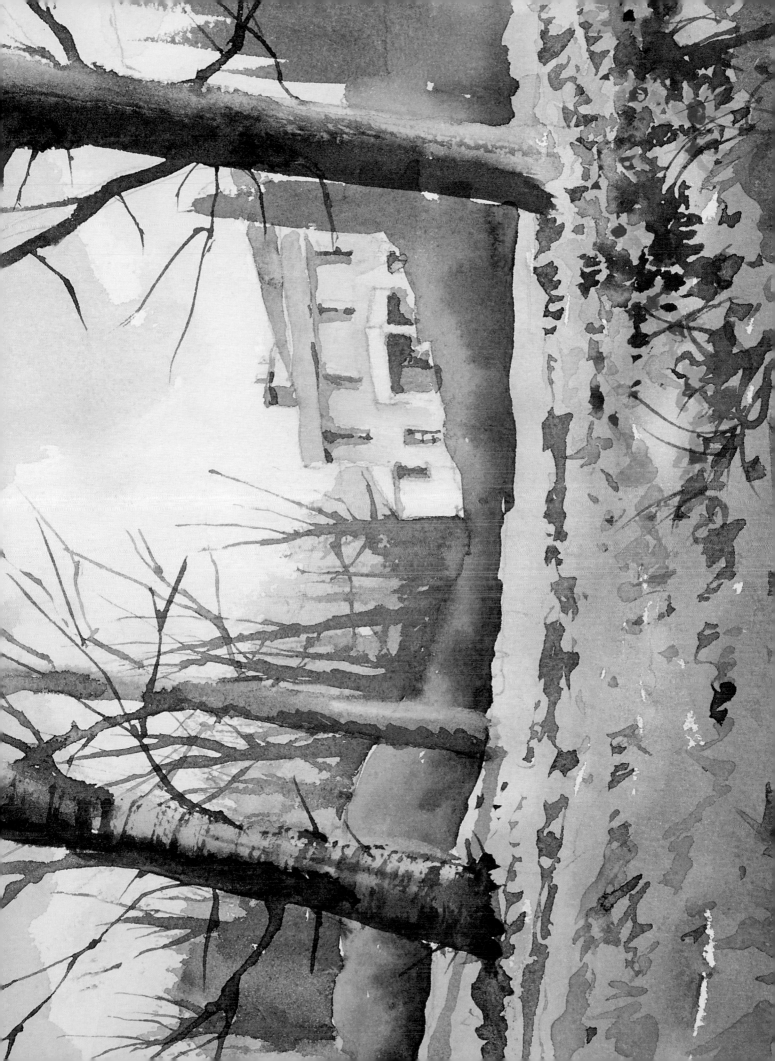

6. SNOW SCENE

Snow is a really popular subject for watercolour, but sometimes for the wrong reasons. It is often assumed that the snow can simply be left as white paper but this tends to lead to a lack of depth and the white of the paper can often be too cold. To be successful, snow scenes need some warmth as well as coolness.

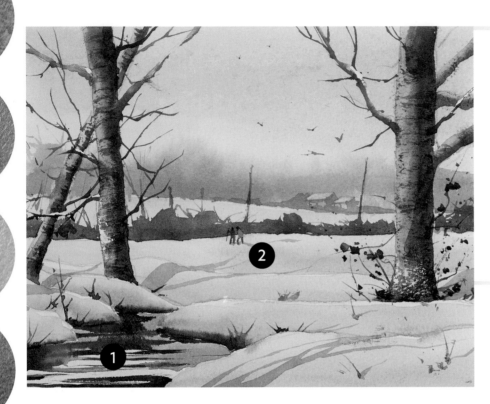

BEFORE YOU START

YOU WILL NEED
Wash brush, medium and small round brushes, sword liner, outline 6 (see page 103)

COLOURS NEEDED
Cobalt blue, French ultramarine, burnt sienna, pyrrole (Winsor) red, quinacridone gold

Technique 1: Still-water reflections

The smoother the surface of the water, the more defined the reflections will be. If the water is completely smooth the reflections are a mirror image of the objects being reflected. As this can be a little artificial-looking, try to hint at a little movement in the water by extending the reflections horizontally as well as lifting out little lines of light to suggest ripples.

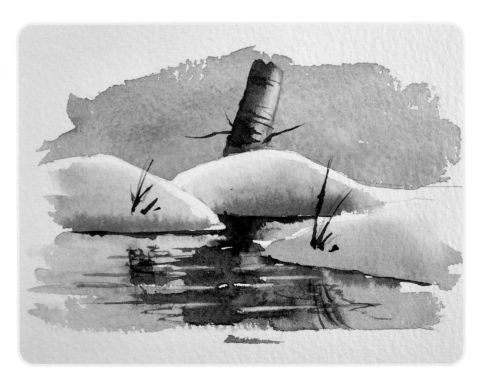

Technique 2: Figures in a landscape

Figures will always make a painting more interesting, but as with other landscape elements it is important that they become part of the landscape, rather than dominate it.

1 It is vital that your figures are in proportion. This is really all that matters for distant figures in a landscape. Begin with a simple stroke of the brush. For this exercise, colour is not that important but I am using my trusty French ultramarine with burnt sienna.

2 Paint a second stroke halfway down the first. Bend the second stroke slightly in the middle. This gives you a basic body shape, trunk and legs and even a knee.

3 Gradually widen the trunk to a more appropriate bulk.

4 Add an arm holding a stick and add a hat a little above the neck area. Although we have not painted a face, the face is implied by the proportions.

5 The second figure is slightly more erect but is painted in much the same way. The blob for the trunk is roughly twice as high as it is wide.

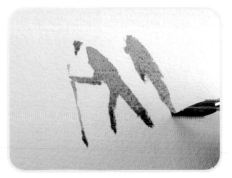

6 Figure measurements can get quite complicated, but it is approximately the same distance from the feet to the top of the legs as it is from the top of the legs to the top of the shoulders.

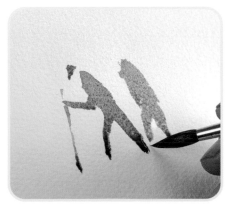

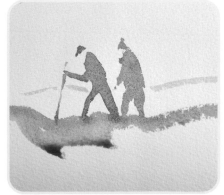

7 If your proportions are reasonably correct and if the legs are positioned so that the body can't fall over then your figures will look believable.

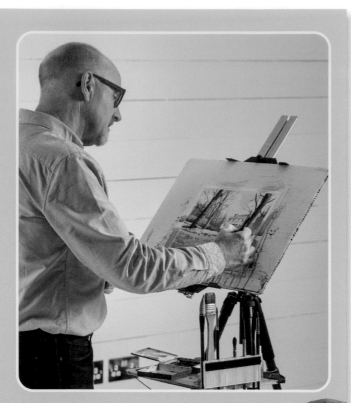

Grahame's top tip

I always paint standing up with my board on an easel (it is actually an adapted photographic tripod) with all of my materials on a tray fixed to the tripod legs. This gives me complete freedom of movement when painting and I can easily step back to get a better impression of the painting as a whole. If standing is not possible, I would still suggest using an easel or some other system where your materials are conveniently placed and you can get back from your painting. I know quite a few folks who paint while balancing brushes, paper, paint and water on their knees. I can admire their dexterity, but painting is difficult enough without combining it with a juggling act.

THE PAINTING

1 Transfer the outline from page 103. Keep the lines that will be in the snow areas quite faint, as the washes will be comparatively light here and too strong a pencil line will be too dominant.

2 Cobalt blue is a great colour for snow scenes as it gives just the right degree of coolness. Start with your big wash brush and a wash of pure cobalt blue and paint down to the bottom of the sky.

3 At that point, add a little burnt sienna and continue to the bottom of the paper. The burnt sienna is quite weak, maybe too weak, but you are after a hint of warmth rather than orange snow, so err on the side of caution.

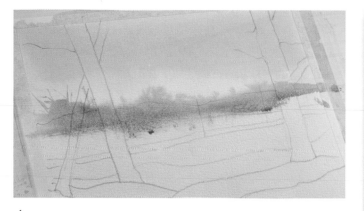

4 While the first wash is still damp, introduce an uneven line of stronger cobalt blue to suggest the middle-distance trees. This will soften to a suitably vague appearance.

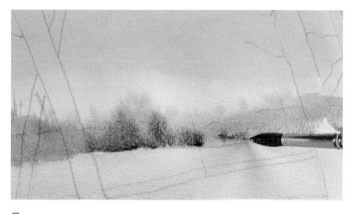

5 Changing to your medium round brush, mix a little pyrrole (Winsor) red with your cobalt blue and drop this into parts of the tree section to give a little variety.

Grahame's top tip: blotting

You can see how the cobalt blue wash has run down into the snow field. Fold a square of kitchen roll (paper towel) in half to get a good straight edge and press it very firmly on your snow field with the edge at the bottom of the trees. This lifts the excess blue paint and dries the watercolour paper enough to prevent a recurrence.

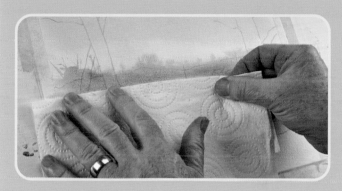

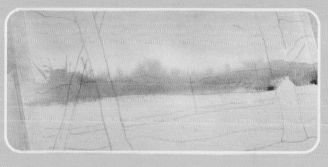

6 Using a paper towel, you can also remove paint from your trees. This is not usually needed in general landscapes, but can be helpful in snow scenes.

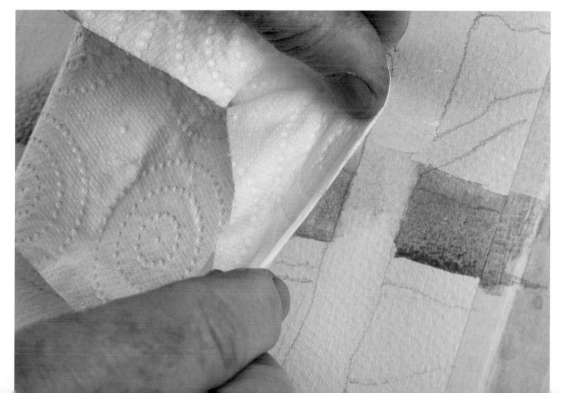

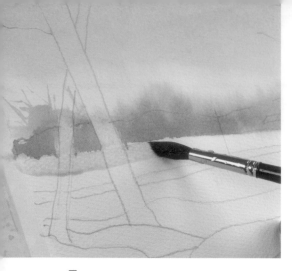

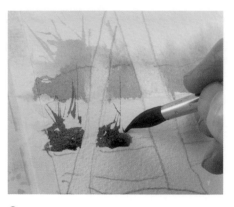

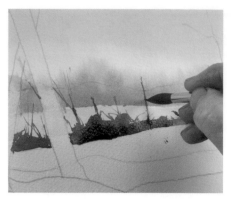

7 In order to achieve a sense of depth, paint the most distant snow field all over with a weak wash of cobalt blue. This cools it and pushes it back.

8 When this is dry, begin to paint the closer line of trees and shrubs. You may not know how light you will need the foreground trees to be, so it could be a good idea to paint around the foreground trunks. Painting around a complex outline would be inadvisable, but the trunks have simple straight edges.

9 Telegraph poles are a fairly standard size around the world, so their size in relation to the foreground trees helps us with a sense of scale and distance. A good point on your brush helps. Paint them either very slowly or very quickly. Somewhere in between will probably cause you to paint wobbly poles.

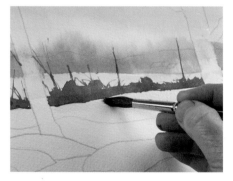

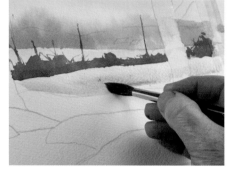

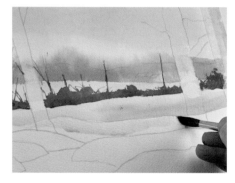

10 Clean up the bottom line of the trees. This edge is really the edge of the snow before it drops down to meet the trees, so although you are painting the trees, you are really painting the edge of the snow!

11 On to the middle snow field now. This should be lighter at the top to suggest that there is a slight hill, so begin with a wash of plain water.

12 The wash is strengthened with cobalt blue as you go down. It is a graduated wash and as with all graduated washes the change from light to dark must be gentle rather than abrupt.

13 Now do exactly the same thing with all of the little hillocks of snow in the foreground. It is best to leave each hillock to dry before starting the next so that you get a good crisp edge. If this edge softens it will not have the overlapping shape effect.

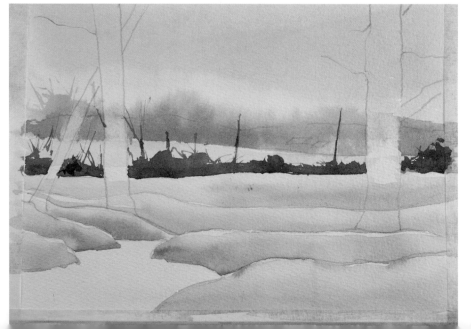

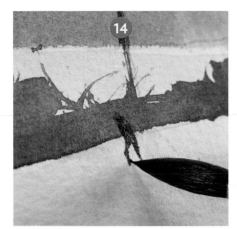

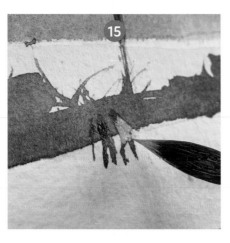

14 Paint a couple of distant figures just as on page 85.

15 They look a little too bland, so give one of them a coat of cadmium yellow.

16 On to the main trees now. Begin with a warm wash over the whole of the trunk. Quinacridone gold and a touch of burnt sienna works well but again, don't worry too much about the precise colour. The tone and warmth/coolness are much more important than the actual hue.

17 Use a strong French ultramarine and burnt sienna mix down the right side of the tree. When dropping in colour like this remember that the wet paint already on the paper will dilute what you add so you must therefore use a stronger mix than if you were painting on to dry paper.

18 Using the same mix, paint a few side branches with your sword liner.

19 While the first tree dries, paint the right hand tree in exactly the same way. Notice that the warm wash is deliberately not the same colour. Variation is good.

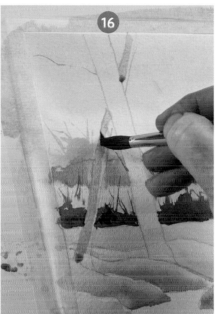

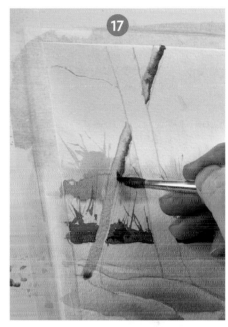

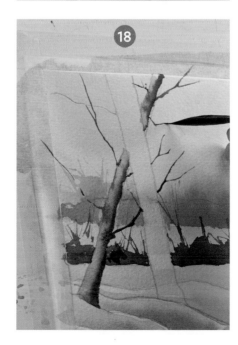

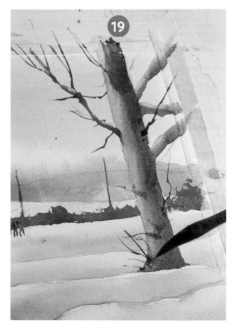

Grahame's top tip: adding warmth

Many years ago an art dealer acquaintance gave me a tip about snow paintings. He told me that snow paintings that were painted only in cold colours never sold. They always had to have some warmth in them. The sun is lower in the sky in winter and so the light is, of course, actually warmer, but I think that human nature generally desires warmth rather than coldness. I love to sit at a warm fire looking through a window at the snow. Not so much fun in reverse!

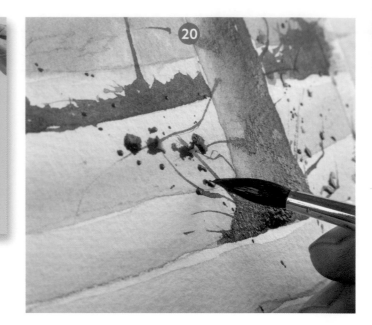

20 Beech trees often keep at least some of their leaves right through winter and a splatter of burnt sienna is a simple way of suggesting this as well as gaining some of that all-important warmth.

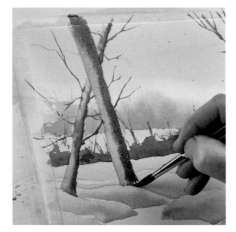

21 Paint the large tree on the left in exactly the same way as the previous trees except you should use weak burnt sienna for your initial warm wash.

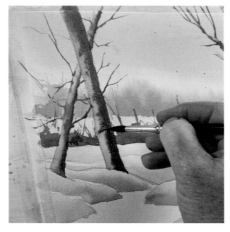

22 The dark dropped-in paint has not drifted as far as it should have, so use the point of your dampened small round brush to gently tease it across.

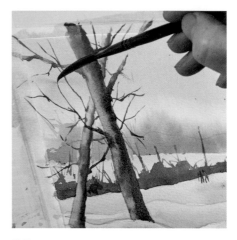

23 The sword liner has a comparatively long hair length, so much so that it is a 'wobbly' brush. The long hair length absorbs small hand tremors and this is why it is so good at straight lines. Again remember to paint the twigs of this type of tree with quick, jerky movements rather than smooth and curvy.

24 Using a wash of cobalt blue and quinacridone gold, paint the reflections in the water. Start your mix with cobalt blue and gradually add touches of quinacridone gold until you get a cold blue/green. In general when mixing colour, start with the dominant colour. The one in the image opposite is more blue than yellow.

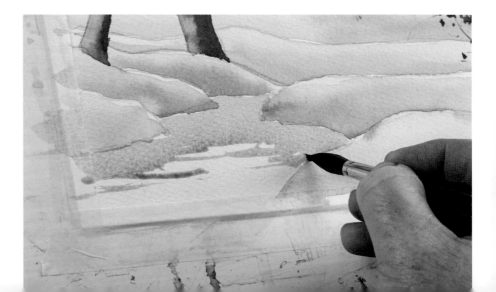

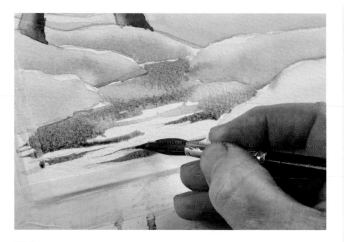

25 While the reflections are still damp, add touches of the same mix but stronger.

Grahame's top tip: timing

Controlling wet-in-wet painting is tricky because it is largely down to intuition and 'feel' and these only come with experience. Try to make your first wet wash as even as possible. If the wash is applied more heavily in some places, these areas will take longer to dry and make the wet-in-wet parts harder to manage. If you go in too early with your second wash the paint will drift too much. Too late and it won't drift enough. Above all else always add strong paint to weak. If you do it the other way around you will almost certainly get cauliflowers (runbacks).

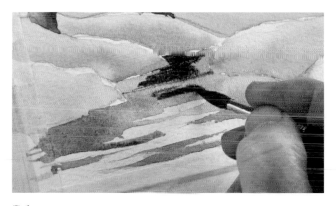

26 The reflections should be still damp but drying as you add some strong French ultramarine and burnt sienna for the darkest reflections. Use a horizontal motion of the brush to emulate the ripples.

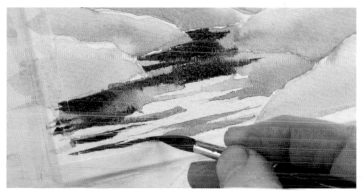

27 Continue down the reflections and finish with a few thin strokes of your dark on the dry parts of the paper. Again, create variety by making some edges soft and some hard.

28 When working wet in wet you will rarely get the precise effect you seek. It is better to accept this rather than to fiddle too much. You will be surprised how often something you felt didn't work looks much better after a cup of coffee! To finish this section, slightly dampen the bottom of each snow bank and immediately paint in a line of very dark French ultramarine and burnt sienna mix. This gives a hard edge at the waterline and a slightly soft edge above. For this to work, you must dampen at least twice the area you wish to paint. In other words, there must be an area of dampness above the edge of your dark stroke in order to achieve the soft edge.

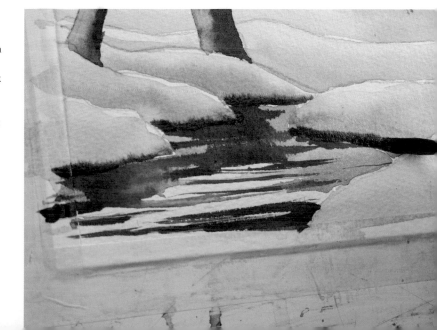

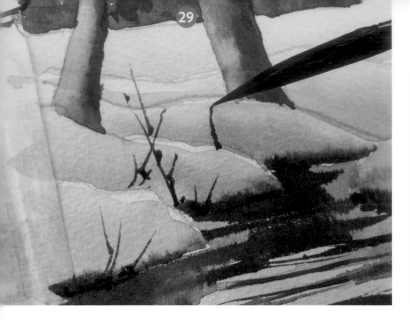

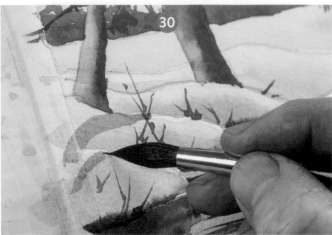

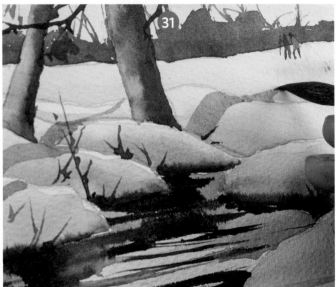

29 It is usually the small brushstrokes at the end of every painting that make or break it. Although these marks will mostly be dark or very dark, they add sparkle to the painting. We tend to think of sparkle as light marks, but really it is the juxtaposition of dark and light marks. Start with some strong burnt sienna and a touch of ultramarine to simply indicate some grasses and twigs coming through the snow.

30 Use a cobalt blue wash with just a touch of pyrrole (Winsor) red for the shadows. Be careful to paint the shadows in a way that describes the pillows of snow, curving up and over where they disappear, and then reappear in a slightly shifted position.

31 Shadows on snow are almost always smoothly curving. Avoid hard angled changes of direction.

32 There are a couple of little buildings in the distance. If you had painted around the roofs when you applied that wash it would have left a very hard edge. Lifting out the light on the roof gives a softer edge more suited to distance.

33 When the lifted parts have dried, paint all of the shadows, windows and doors with a simple, single continuous wash using the same shadow wash with slightly less pyrrole (Winsor) red.

34 If you stop there, the buildings will command too much attention, so continue the wash on both sides of the buildings, suggesting some more vegetation in the distance and reducing the importance of the buildings.

35 Don't forget the little shadows cast by the protruding grasses. Again think of the slope and curve of the surface the reflections are cast on.

36 The drybrush bark on the trees really adds to the illusion of realism. Use burnt sienna and ultramarine again. A nice stiff mix worked into the brush will help. To complete the illusion, the bark marks should have a slightly upward curve above the horizon.

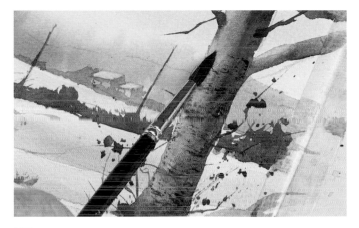

37 The bark marks should be horizontal at the horizon and slightly downward curving below the horizon. This is the effect of perspective on a cylinder.

38 Snow scenes can have a rather empty feel to them. A few birds help to add interest. Keep them simple but varied and be careful of their size. They are not 'm'-shaped and they are not pterodactyls!

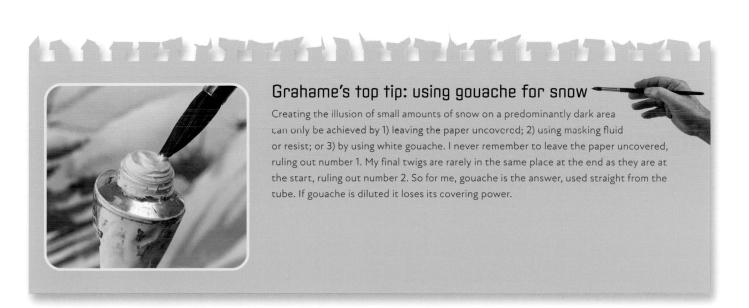

Grahame's top tip: using gouache for snow

Creating the illusion of small amounts of snow on a predominantly dark area can only be achieved by 1) leaving the paper uncovered; 2) using masking fluid or resist; or 3) by using white gouache. I never remember to leave the paper uncovered, ruling out number 1. My final twigs are rarely in the same place at the end as they are at the start, ruling out number 2. So for me, gouache is the answer, used straight from the tube. If gouache is diluted it loses its covering power.

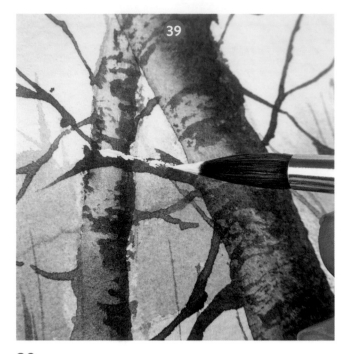

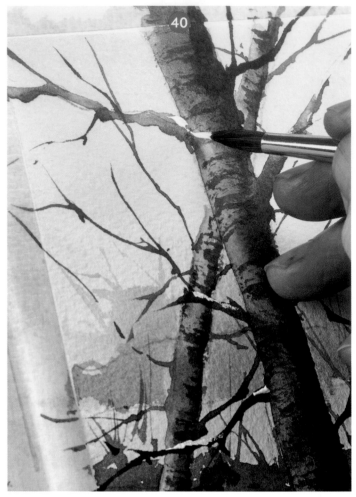

39 Dipping the small round brush straight into your tube of gouache allows you to accurately place snow wherever you please.

40 The gouache is pure and undiluted so it has a sticky texture and easily gives a drybrush effect. This is ideal to suggest the slightly uneven covering on twigs and branches.

41 Finally, with your brush slightly fuller, make a sideways motion with the side of your brush to give that slightly dusty appearance of blown snow.

Grahame's top tip: removing pencil lines

Take this opportunity to remove any visible pencil lines from the transferred outline.

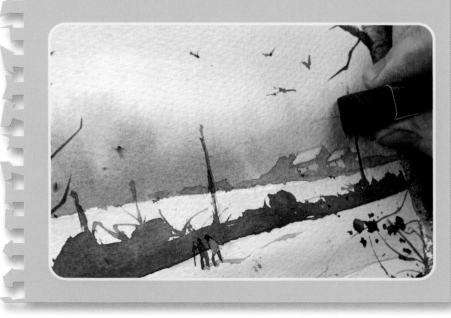

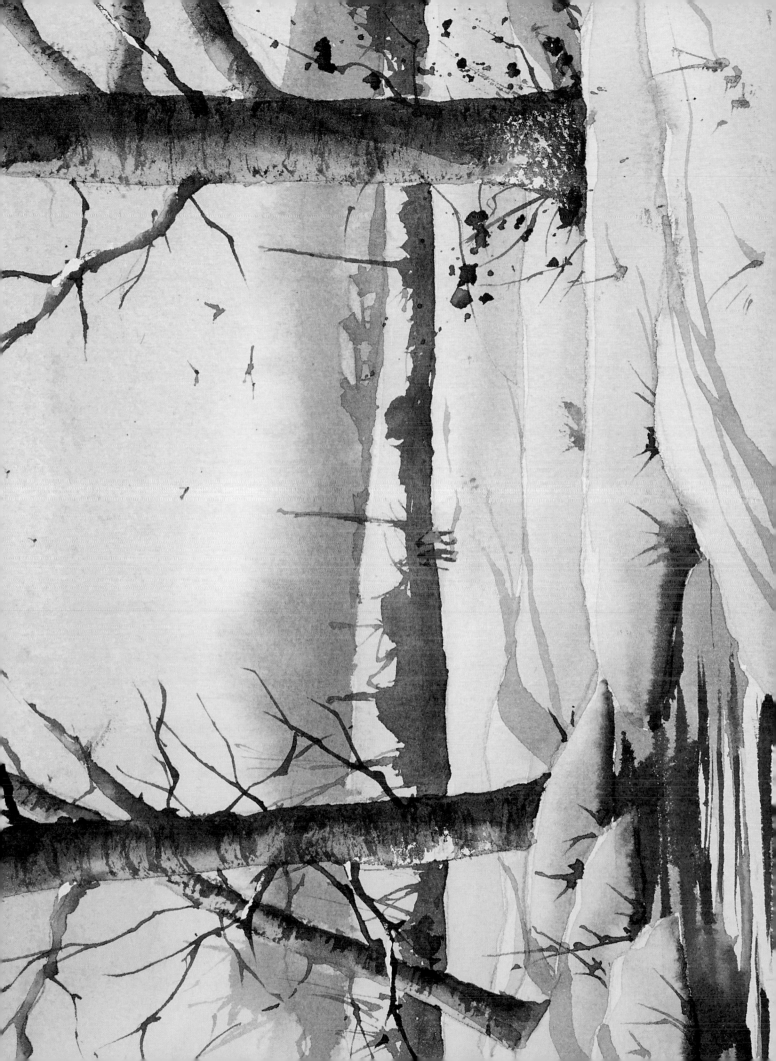

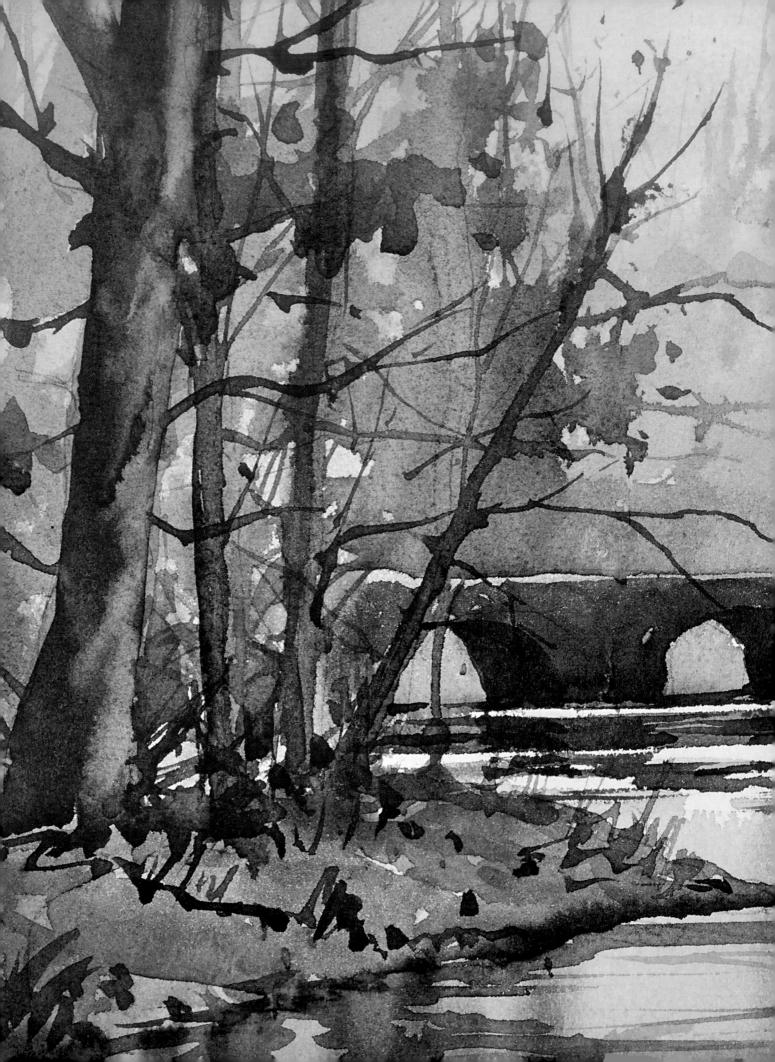

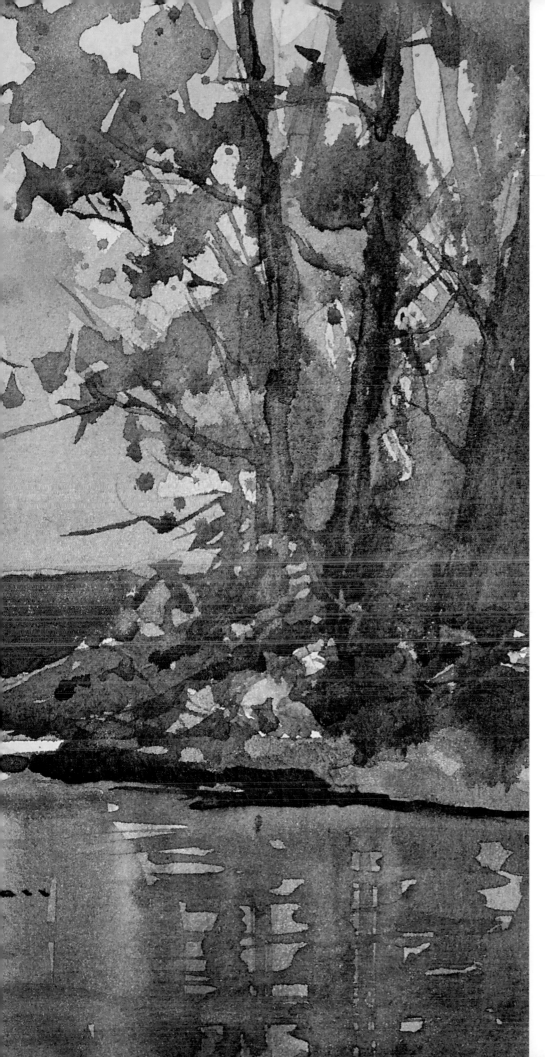

Project 3: *River and Bridge*,
pages 46–59.

THE OUTLINES

Extra copies of the outlines are are available to download free from the Bookmarked Hub.
Search for this book by title or ISBN: the files can be found under 'Book Extras'.
Membership of the Bookmarked online community is free: www.bookmarkedhub.com

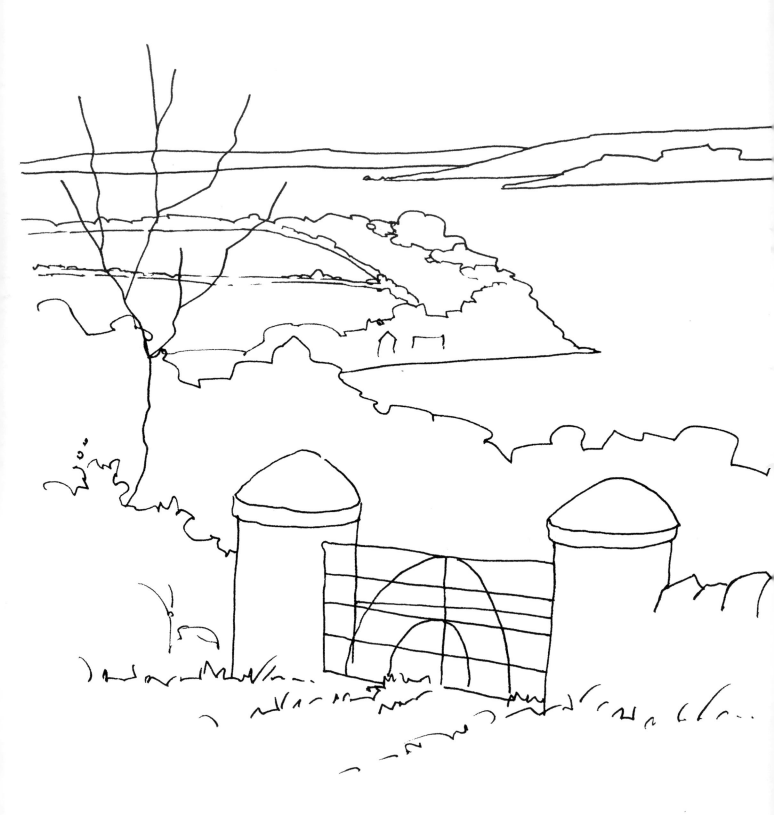

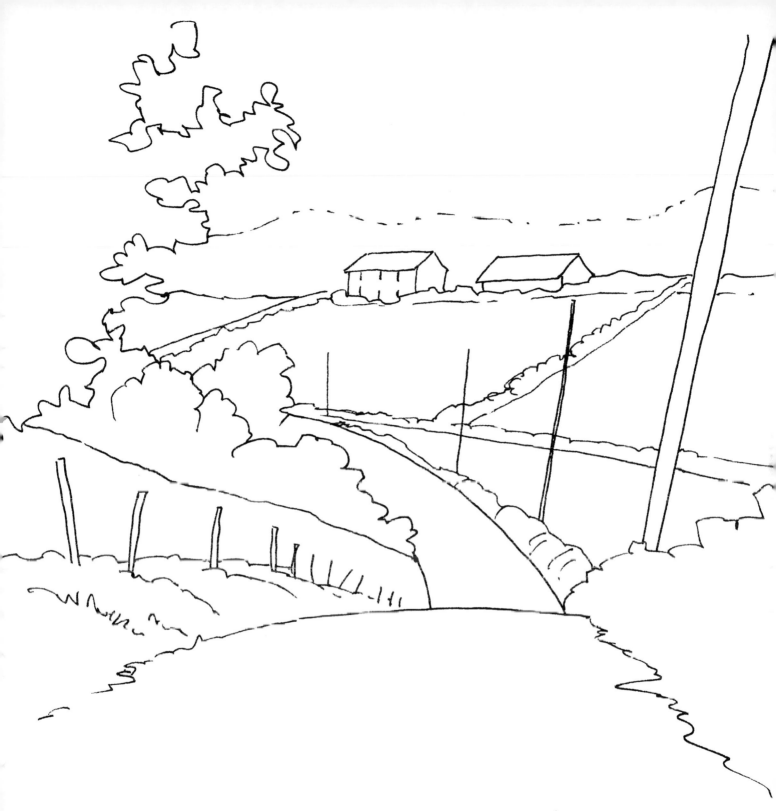

2

5

INDEX

background 24, 29, 30, 32, 41, 50, 51, 79
bead of paint 14, 15, 35
 pulling into the brush 14, 24
blotting 11, 75, 87
board 8, 9, 22
bridge 46, 52, 55, 58
brush
 full 13, 14
 how to hold 12, 56
brushes 6, 11, 20, 23, 26, 27, 35, 38, 43, 47, 49, 51, 52, 53, 54, 55, 56, 63, 66, 67, 73, 76, 79, 80, 81, 86, 87, 89, 90, 94
brushstrokes
 angled 60
 directional 60
 horizontal 60, 65, 91
 vertical 60, 63, 65, 78, 79
buildings
 creating distant 38
 integrating into landscape 72

cauliflowers see runbacks
clouds 11, 22, 34, 75
colour bias 17
 primary 15
 secondary 15

depth see distance
distance 20, 21, 41, 88

excess drips, removing 24

fence 33, 39
field 6, 26, 36–37, 40, 69, 87, 88
figures 85, 89
flowers 72, 74, 76, 80
foreground 20, 24, 25, 32, 37, 40, 47, 58, 60, 62, 63, 67, 74, 77, 88
framing 17

gate 20, 24–27, 30
gouache 20, 30, 93, 94
grass 21, 24, 26–27, 37, 40–41, 49, 56–57, 63–70, 72, 75, 77, 81–82, 92–93

hard edges 28, 37, 38, 54, 66, 76, 78, 88, 91, 92
hedge(row) 24–27, 36, 39, 41, 43
highlights 30, 62, 65, 66
horizon 22, 33, 93

image, transferring 8

leaves, creating 6, 43

masking tape 9, 11, 22, 34, 79
middle distance 36, 40, 47, 52, 58, 87
mountain 6, 32, 33, 60–63, 70, 72

objects
 overlapping 21
 repeating objects 33
 separate 21
outlines 11, 12, 20, 22, 32, 34, 46, 50, 60, 61, 70, 73, 75, 85, 86, 88, 94, 98–103
 making copies of 8

paint 11
 drifting across 42, 48
 from the top down 26, 27
 pulling into the brush 14
paintbox/palette 11
pencil lines, removing 70, 94
people see figures
perspective
 aerial 20, 21, 38, 47, 70
 creating 33
 effects of 42, 93
 preparation 12
 proportion 85

reflections 48–49, 51, 55, 56, 58, 68, 84, 91, 93
 still-water 84
ripples 48, 56, 84, 91
river 33, 46, 48, 50, 53, 55, 56, 60, 62, 65
road 24, 32–44
rocks 6, 65, 66, 68, 70
runbacks 14, 24, 35, 91

seasons 54, 55, 57, 58, 72, 73, 90
shadows 28, 42, 44, 62, 63, 69, 78, 82, 92, 93
shapes
 connecting 21, 27, 38, 40, 48
 overlapping 79
 simplifying 46, 52
sharing your work 17
silhouettes, painting convincing 32
simplification 20
sky 11, 22, 23, 34, 49, 50, 61, 75, 78, 86, 90
snow 54, 60, 61, 84, 86–94
soft edges 11, 28, 29, 35, 38, 54, 72, 76, 91, 92
sponge 11, 22, 72
 rinsing and squeezing 22, 75
spray bottle 11, 20, 65

techniques 9
 blending 51, 54, 77
 colour mixing 13, 16
 drybrush effect 14, 38, 40, 47, 73, 81, 93, 94
 general 12
 lifting out 11, 41, 47, 49, 57, 79, 84, 92
 softening 11, 29, 38
 splattering 25, 52, 53
 spraying 11, 22, 50, 51
tone 15, 33, 41, 47, 64, 81, 89
tracing paper 8
trees 6, 21, 24, 37, 43, 47–48, 56–58, 63, 67, 76–82, 87, 89–90, 93
 winter 73

variety, creating 33, 36, 40, 43, 47, 64, 66, 91

wall 21, 25, 60, 78
warmth, adding 90
washes
 connecting 55, 61
 continuous 23, 92
 creating graduated 15, 88
 creating smooth, wet 14
 flat 15
 uneven 8
water, adding 13
watercolour paper 8, 11
 securing 9